# CARRYING COAL
## to
# COLUMBUS

### Mining in the Hocking Valley

DAVID MEYERS, ELISE MEYERS WALKER & NYLA VOLLMER

THE
History
PRESS

Published by The History Press
Charleston, SC
www.historypress.net

Copyright © 2017 by David W. Meyers, Elise Meyers Walker and Nyla Vollmer
All rights reserved

First published 2017

Manufactured in the United States

ISBN 9781467135498

Library of Congress Control Number: 2016953258

*For my grandson, Ford.*

*Tag, you're it!*

# CONTENTS

# CONTENTS

# ACKNOWLEDGEMENTS

Everyone's a historian in the Hocking Valley—or at least it seems that way. As a group, they are uncommonly generous with their time, knowledge and collections. We would like to thank Mike Tharp for the photographs from the collection of his late brother, Wesley Tharp; William E. Dunlap; Cheryl Blosser/New Straitsville History Group; Nyla Vollmer, Bruce Warner; and the Columbus Citizen/Citizen Journal Collection at the Grandview Heights Library. Evelyn Keener Walker and Cheryl Blosser deserve special recognition for their editing advice.

We also benefited indirectly from the work of historian Dr. Ivan Tribe of Rio Grande University and John Winnenberg of the Little Cities of Black Diamonds Council, both of whom have done so much to preserve and promote the history of this region. Along with Cheryl, Nyla and other true believers, they have been striving for decades to develop the region into a tourist destination, thereby ensuring its continued existence as a living museum. It hasn't been easy, and it's far from done. Perhaps this book will help.

# INTRODUCTION

*The next thing you will call to mind is that this coal burns and gives flame and heat, and that this means that in some way sunbeams are imprisoned in it.*
—*Arabella B. Buckley,* The Fairy-Land of Science *(1890)*

Coal made America great. Our nation was built on it—literally and figuratively. Blessed with some of the largest and richest coal deposits in the world, the United States evolved into an industrial powerhouse during the second half of the nineteenth century thanks to this organic sedimentary rock. For better or worse, the acquisition, transport and processing of coal shaped the development of our cities and reshaped the appearance of the land. Coal determined the location of towns. Coal dictated the routes of canals and railroads. Coal influenced the evolution of society. In recognition of its value, lumps of coal came to be called "black diamonds."

During the American Civil War, Ohio evolved into a major industrial center when three ingredients—coal, iron and steam—were brought together. Coal was used to make iron, iron was used to make steam engines and steam engines were used to mine and transport coal. The state's premier industries—steel, rubber, glass and clay—were all heavy consumers of coal. When Samuel Harden Stille called his history of the Buckeye State *Ohio Builds a Nation*, it wasn't far from the truth.[1]

In *Carrying Coal to Columbus: Mining in the Hocking Valley*, we take a look at the nearly forgotten role that Columbus played in opening up the coal fields of the Hocking Valley, helping to fuel and finance the Industrial

# INTRODUCTION

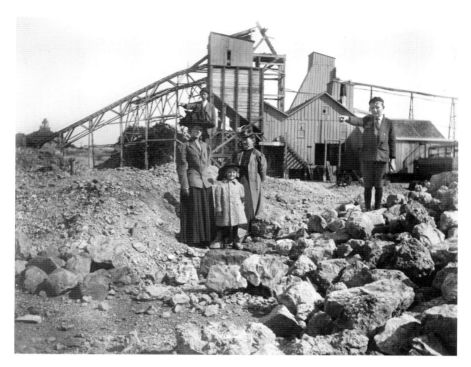

A family outing to an Ohio coal mine. *Authors' collection.*

Revolution. The existence of coal deposits in the Ohio Country had not gone unnoticed by the region's earliest visitors, particularly where there were exposed outcroppings that could be easily exploited. The word *coals* appears adjacent to the Hocking River near present-day Athens County on *A Map of the Middle British Colonies in America*, published in 1755. These deposits formed part of the vast Appalachian Bituminous Coal Field, which underlies much of Ohio, as well as states to the east and south.

The availability of coal alone does not make for a coal industry. It had to be first dug out of the ground and transported to market. The Ohio mine owners were feudal princes at best and robber barons at worst. They carved out kingdoms in the hills and hollows of the Hocking, Mahoning and Tuscarawas Valleys and endeavored through an unending series of mergers and acquisitions to consolidate their power. They amassed, and sometimes lost, huge fortunes—obtained through what some might call immoral and unethical business practices, while others would chalk it up to pure, unfettered capitalism. As is usually the case, the truth lies somewhere in between.

# INTRODUCTION

At the beginning of the twentieth century, there were an estimated fifty thousand workers and their families living in the mining towns that dotted the counties of Athens, Hocking and Perry. Today, the number has dwindled to about fifteen thousand. In most cases, when the mines played out or were abandoned, the town followed suit as the miners moved on in search of work. The communities that developed more diverse economies have managed to survive, if not exactly prosper, reflecting the general economic malaise that characterizes that corner of Appalachia.

Many Ohioans are proud to be descended from these intrepid people. As the late *Columbus Dispatch* columnist Mike Harden, the grandson of a coal miner, grimly observed: "Their collective heritage tells the story of men who, for decades, went to work in the dark and came home in the dark, their world illuminated mostly by the candlepower atop their miners' caps. Dying was the only way for them to move up in the world, from the deep shafts they worked to the shallower sod of their graves."[2]

Joining me in telling this story are my daughter and frequent collaborator, Elise Meyers Walker, and our friend, Nyla Vollmer, who has been active in collecting and documenting the history of the region for many years. It is our hope that by chronicling the development of these coal fields through the prism of the coal barons and union leaders, many of whom made their homes in Columbus, we will renew interest in this vanishing part of our history and encourage others to join the efforts to preserve and restore the remnants of these Hocking Valley mining towns—the "Little Cities of Black Diamonds."

DAVID MEYERS

# FITS AND STARTS

*The town is clean and pretty, and of course is "going to be" much larger. It is the seat of the State legislature of Ohio, and lays claim, in consequence, to some consideration and importance.*
*—Charles Dickens,* American Notes *(1842)*

On the whole, Charles Dickens had been disappointed by his first tour of the United States. The country was simply too backward for his tastes and made the thirty-year-old writer homesick. Viewed in that light, his mention of Columbus, though brief, was surprisingly positive—allowing for a measure of his usual sarcasm. Had he visited the town twenty years earlier, however, it is unlikely he would have been as charitable. It was not particularly clean or pretty. And its prospects did not look especially bright.

"The years 1819 and 1820, to 1826," wrote William T. Martin, "were the dullest years in Columbus [history]."[3] Martin would know. He was the mayor from 1824 to 1826, as well as the town's first historian. Little more than a crossroads carved out of nearly unbroken forest, Columbus started out with no human inhabitants and wouldn't officially become a city until 1834, when the population topped four thousand. But from 1820 to 1825, business was at a virtual standstill. A great depression had shaken the local real estate market. Money was hard to come by, and numerous lots went unsold at a sheriff's sale, even at two-thirds of their appraised value.

Conceived as Ohio's capital, Columbus was voted into existence in 1812, when the state legislature, meeting in Zanesville, decided to locate the seat

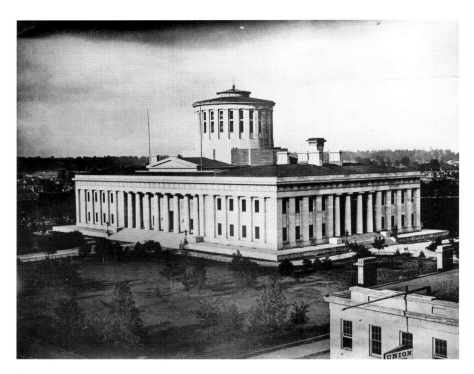

After twenty-two years, the Ohio Statehouse was finally completed in 1861. *Library of Congress.*

of government on the "High Banks opposite Franklinton at the Forks of the Scioto known as Wolf's Ridge."[4] Four years were to pass before the newly incorporated town was sufficiently developed to assume the attendant responsibilities. Even then there wasn't much to recommend it.

In a letter to relatives back in Pennsylvania, Betsy Green Deshler lamented, "[A]ll sick, all trouble, everybody dying and, as a poor Negro says, 'everybody look sorry, corn look sorry, and even de sun look sorry, and nobody make me feel glad.'"[5] But things were about to change, and although Betsy would not live to see it, David Deshler, her cabinetmaker turned banker husband, would play a major role.[6]

It started with Joseph Ridgeway. Having failed at business in Cayuga, New York, Ridgeway came to Columbus in 1821 for a fresh start. The thirty-eight-year-old carpenter had devoted half a year to perfecting the design of a new cast-iron plow in partnership with Jethro Wood, generally credited as the inventor of the modern plow. By the following spring, Ridgeway had established the town's (and the state's) first iron foundry on Scioto Street with

his nephew, Joseph Ridgeway Jr. To fuel their furnace, they used charcoal, owing to the abundant supply of timber from which to make it.[7]

Three days a week, the Ridgeways traveled more than thirty miles to the Granville Furnace with a two-horse wagon to purchase pig iron (smelted iron ore).[8] In 1830, the two men converted their foundry to steam power, replacing the old horse that worked an inclined wheel some thirty feet in diameter. This enabled them to manufacture machinery, steam engines, stoves and other hardware. With the fortune he accumulated from Columbus's first successful manufacturing enterprise, Ridgeway Sr. soon repaid all of his creditors back in New York and had some left over.

Others came in search of opportunity. The population was approaching two thousand when Boston-born John Loriman Gill and Colonel James

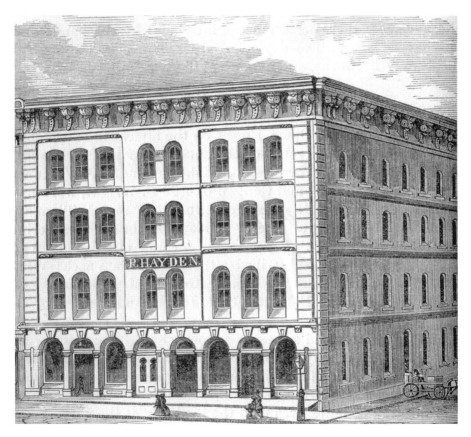

Capitol Square has been home to the Hayden-Clinton Bank building since 1869. *Authors' collection.*

Greer of Dayton moved to Columbus in 1826. Within three years, the partners began selling stoves made for them at the Mary Ann Furnace, ten miles north of Newark.[9] These stoves were the first ever brought to Columbus, "but it was an uphill business disposing of them."[10] Seeking new markets for their wares, they looked to the resource-rich Hocking Valley of southeastern Ohio.

On an April day in 1830, Gill decided to drive four six-horse wagonloads of stoves to Athens, about seventy-five miles distant as the crow flies. Along the way, he passed a blacksmith in Nelsonville who was using coal he had mined in his garden to fuel his forge. Instead of returning home with empty wagons, Gill arranged for the blacksmith, James Knight, to load two of the wagons with fifty-eight bushels of coal at a cost of four cents per bushel. It's unlikely that Knight was aware that his garden sat atop a three-bench seam of Middle Kittanning coal that extended beneath the northern half of Athens, the eastern edge of Hocking and the southern third of Perry Counties, but in time, the entire nation would hear of it.[11]

Back in Columbus, Gill sold his coal to William A. "Billy" Neil, operator of a successful tavern and stagecoach line, for fifteen dollars per ton. It was the first shipment of coal ever brought to Columbus.[12] Only twenty-one or twenty-two years old at the time, Gill would later become the first president of the Columbus Board of Trade. And Neil would go on to build the acclaimed Neil House Hotel, whose guests included the renowned writer Charles Dickens (when it was still under construction) and future president William McKinley.[13]

Seeking new worlds to conquer, Peter Hayden came to Columbus in about 1834 from Auburn, New York, where he had contracted with Auburn Prison for the use of convict labor in the manufacture of tools and saddlery hardware. Born in Onondaga, New York, in 1806 and reared in Cummington, Massachusetts, it is likely that Hayden was attracted to central Ohio by the abundance of timber and the availability of an inmate workforce.[14] On June 10, 1835, he became the first person to contract with the Ohio Penitentiary for the use of prison labor, ushering in a system that would be as controversial as it was profitable.

Initially, fifty to one hundred felons were hired to make saddle-trees, bridle-bits, stirrups and more. An Anti-Prison Monopoly Association, composed of mechanics and other workingmen of Columbus, soon rose up to petition the General Assembly to abolish this "unjust system," which provided an unfair competitive advantage through the use of cheap labor.[15] This was one of the earliest stirrings of a labor movement in

Ohio. Four years later, in 1848, about fifty journeyman carpenters would go on strike, parading through the streets of Columbus behind a band and carrying a banner with the message "$1.50."

Even as he was getting established in Columbus, Peter Hayden continued to grow his other interests, opening an additional factory in New Jersey and introducing the use of prison labor in California. As his product lines expanded, Hayden established wholesale stores in major cities on both coasts. He also founded the Hayden Iron Works, yet another prison industry, and offered prison-made carpets a decade later. In all, Hayden operated foundries, rolling mills and other enterprises in Pittsburgh, St. Louis, San Francisco, Los Angeles and New Jersey—all from his home base in Columbus.

Within fifteen years of his arrival, Hayden owned real estate in Franklin County valued at $500,000. Few business opportunities escaped his notice. The only thing holding him back was the deplorable condition of Ohio's roads, which were pretty much useless for commerce.[16] But the problem wasn't his alone.

Long before Ohio became a state, there was talk of building a canal linking Lake Erie to the Ohio River. As early as 1787, George Washington, who knew the territory from his youthful days as a surveyor, and Thomas Jefferson had discussed the idea. But nothing was done about it until February 4, 1825, when the Ohio legislature passed "An Act to Provide the Internal Improvement of the State of Ohio by Navigable Canals." Six months later to the day, the first spade full of earth was turned at Licking Summit near Newark. Two years after that, the first boat was launched on the Ohio & Erie Canal in Akron and reached Cleveland the next day—a distance of thirty-seven miles.

A Portage County entrepreneur hit on the idea of shipping coal to Cleveland by the newly constructed channel in 1828. As a result, steamboat operators, who had previously been using firewood to traverse Lake Erie, started substituting coal because of its greater efficiency as a fuel. Soon, the steamboats cruising on the Ohio River also converted to coal power. During the next five years, the in-state waterway was expanded from Akron to Chillicothe via Massillon, Dover and Newark.

The first major development in exploiting the coal mining potential of the Hocking Valley was the completion of the Ohio & Erie Canal system. On September 23, 1831, a feeder canal from Lockbourne reached Columbus. One year later, the final leg of the Hocking branch was opened, connecting Lancaster to Athens. Both "packet" (passenger) and working boats were soon crisscrossing the state.

The opening of the Ohio Erie Canal made shipping coal from the Hocking Valley possible. *Bruce Warner.*

Halfway around the world, the *Calcutta Review* declared in 1849, "In these days of steam and machinery, nothing prospers without coal."[17] That same year, the first steam-powered packet boat to successfully navigate the Ohio canal system was the *Niagara*, which reached Dayton. It was ten years later, on September 1, 1859, that the steamer *Enterprise* arrived in Columbus carrying 1,700 bushels of coal. Fitch & Son soon began operating the *City of Columbus*, described by Colonel Alfred E. Lee as "a very handsome steam canal packet," between Columbus and Chillicothe on a regular schedule.[18] By then, coal was already being transported all the way to Columbus from the Hocking coal fields, and Hayden was involved.

Exactly when Peter Hayden began building a line of canalboats is unknown, but it probably wasn't very long after he came to Columbus. As early as 1847, he had formed a partnership—Hayden & Somers—with J. Fisher Somers to sell hardware, dry goods, groceries and "COAL! COAL!! COAL!! COAL!!!" to the people of Nelsonville. Although Nelsonville was located in the heart of coal country, the partners' selling points were that their coal was "equal to the Brownsville Coal" and priced at the "lowest rates."[19] At about the same time, Hayden began construction of a three-story house with a cupola on the riverbank at the foot of State Street in Columbus.

# MINING IN THE HOCKING VALLEY

Even as Hayden was shipping his wares to Nelsonville by canalboat, he was thinking of bigger things. In February 1848, the Ohio General Assembly passed an act authorizing the incorporation of Dorr's Run Lateral Canal & Railroad Company in Athens County by Hayden, Somers, John Raine and John and Nicholas Wilkinson. The men planned to make Dorr's Run navigable for canalboats for up to a mile from its junction with the Hocking Valley canal and, from there, build a railroad to their coal mines. Although Hayden was an early booster of railroads, even he probably did not appreciate how rapidly they would come to transform and dominate Ohio's transportation infrastructure for the next century.

# VISIONARIES AND SPECULATORS

*We may well call it black diamonds. Every basket is power and civilization; for coal is a portable climate.*
*—Ralph Waldo Emerson, "Wealth" (1860)*

Three years before Ohio attained statehood in 1803, one hundred tons of coal were mined in what would become Jefferson County. During the next two centuries, more than 3.5 billion tons of coal were produced within the Buckeye State's boundaries, but because Ohio was heavily forested and firewood was plentiful, the demand for coal was slow to develop. The growth of the coal market in Columbus was limited by the small quantities that could be transported by wagon from southeastern Ohio. It wasn't until the arrival of the canal that mine operators had a practical means of transporting significant amounts.

The locus of the Hocking Valley coal fields was southern Perry, western Hocking and northern Athens Counties, particularly along Monday Creek, Sunday Creek, Snow Fork and Brush Fork—a region that until the coming of the railroads was accessible only with difficulty. The earliest speculators—men such as Lorenzo Poston, Peter Hayden, William Barker Brooks and Thaddeus Longstreth—entered the coal business when canalboats were the vehicle of choice for transporting coal to distant markets. All but Poston would live in Columbus, but their story begins in Nelsonville.

In 1814, the same year that the British burned Washington, D.C., Daniel Nelson of Massachusetts purchased two hundred acres of land in York

The Struggling Monkey Mines outside Nelsonville. *Authors' collection.*

Township, Athens County. Four years later, he laid out fifty-seven lots in what would become Nelsonville. At about the same time, George Cortauld was establishing English Town nearby and managed to secure the first post office in the area for his competing settlement. When Cortauld died in 1825, Nelson was appointed postmaster, relocated the post office to Nelsonville and set the stage for it to become the center of the Hocking Valley coal industry. English Town, meanwhile, would vanish into the mists of time.

Originally, the inhabitants of Athens County would gather lumps of coal from the riverbed for their own use. Later, a small mine, possibly the first in the Hocking Valley, was dug outside Nelsonville on the north side of Johnson's Hill to satisfy local needs. Because it was difficult to haul the coal very far, coal mining remained a sideline. Wood—or charcoal made from wood—was plentiful and sufficed for most purposes. But it was just a matter of time before the catalyst for the development of a true coal industry appeared, and his name was Lorenzo D. Poston.

A Virginian from a once prominent family in Hampshire County, eighteen-year-old Poston arrived in Athens County in 1830, having traveled 220 miles by foot. For five years, he hired himself out as a farm laborer while dabbling in cattle trading and digging coal. By 1835, Poston had saved enough money to open a general store in Nelsonville. When the canal arrived five years after that, he seized the opportunity to expand his

business to include the mining and shipping of coal. He would become the first of the Hocking Valley coal barons.

By 1852, Poston owned a large tract of land just outside town and channeled all of his time and effort into growing the mining business. As a result, he was well positioned to take advantage of the arrival of the railroad in 1869, which provided an even better means of transporting his coal. There was even a town named Poston for a time. Two years before his death in 1875, Poston sold his business to his sons, Clinton L. and William W., and they continued to operate as Poston Brothers (later Postons & Pendleton when Lucinda Pendleton, their sister, joined the business). Clinton, who took the lead in running the corporation, helped to organize the Sunday Creek Coal Company in 1905. At its inception, Sunday Creek was the second-largest coal mining company in the world, with thirty-three mine sites in the Hocking Valley and twenty-seven more in West Virginia.[20]

Although he lagged behind Lorenzo Poston by a half-dozen years or so, William Barker Brooks, usually known by the initials "W.B.," soon overtook him as the largest shipper of coal in the region. Born in Castine, Maine, in 1819, W.B. moved to Columbus with his family when he was still a child. They made their home at the corner of Rich and Third Streets.[21] John Brooks, his father, was a merchant, justice of the peace and ninth mayor of the city—the first elected by popular vote. However, he resigned in 1835 after serving one year of a two-year term. When John failed in his own business pursuits, W.B. made him a partner in his wholesale grocery, which was renamed J. & W.B. Brooks. Upon John's death, Alexander Houston replaced him in what was now called Brooks & Houston.

Brooks bought the Vanwormer coal interests in Nelsonville around 1857, becoming a mine owner at the age of thirty-eight. Unlike his competitors, Brooks paid his miners in cash, at least initially. However, he later issued company scrip in order to further increase his personal wealth. By constructing a large basin adjacent to the canal in which five boats a day could be loaded, he was able to build up an extensive shipping operation.[22] As his business prospered, Brooks purchased additional coal fields around Nelsonville and in Vinton County.[23] Then, within a few months of the arrival of the Columbus & Hocking Valley Railroad, the population of Nelsonville, a quiet hamlet on the Hocking Canal, tripled.

In 1871, Thaddeus Longstreth, another Columbus entrepreneur, laid out a subdivision at the east end of Nelsonville and named it after himself. One of eleven children, he was born in 1843 on a farm near Lebanon, Ohio, where he developed a strong work ethic. Educated in the local schools,

including the National Normal University at Lebanon, he dropped out at seventeen to enlist in the Union army. Rising from private to captain, he acquitted himself with courage and distinction in seventeen battles before being mustered out in July 1865.

Finding business in Lebanon too stifling, he set out for Columbus in 1868, determined to work in the coal industry. He soon purchased the interests of W.G. Power and Company. With one mine already operating north of Nelsonville, Longstreth decided to locate a second just north of Monday Creek in Ward Township, Hocking County, in 1880. By the following year, the mine had shipped out nearly seventy-two thousand tons of coal by rail. As of 1883, the village of Longstreth contained sixty-six company-owned houses and a store catering to the 347 miners and their families. Due to its proximity to Nelsonville, Longstreth was composed of both company and private housing. Meanwhile, he operated coal yards in Columbus and became the city's foremost dealer for many years.

There was another, apparently unrelated, Poston who also become a prominent coal operator in Nelsonville. Elias M. Poston, son of Samuel Newton Poston, a Nelsonville hardware merchant and one-time mayor, was a leading figure in the Hocking Valley coal industry for three decades. President of the New York Coal Company, he was an industrialist and financier, well known in the brick and clay industry. Born in Nelsonville in 1862, Poston first went to work in John W. Scott's company store at Lick Run. Later, he was employed as a billing clerk in the town's railroad yards. Barely in his thirties, Poston—in cooperation with Andrew Bauman, G.W. Lamb and others—organized the Columbus, Hocking Valley & Athens Railroad in 1894.

Two years later, Poston secured a five-year contract with the City of Nelsonville to provide a gasoline system for lighting the streets. In 1899, in partnership with David L. Sleeper and John P. McGill, he switched to electrical lights. The operator of the first alternating current generator west of the Alleghenies, Poston became a prominent figure nationally in the lighting industry. What began as the Nelsonville Electric Company evolved into the Hocking Power Company. He continued to expand his business, building a large power station at Floodwood that generated much of the electricity used throughout southern Ohio.

Not surprisingly, Poston entered the coal business as well. In 1899, he partnered with Joseph Slater, Charles Kurtz and others to lease mines at Chauncey and Floodwood, then held by the New York & Western Coal Company. Three years later, he purchased the New York & Western

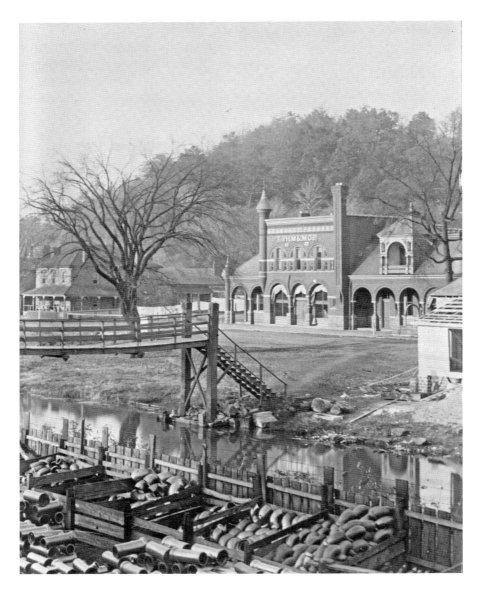

The Haydenville Mining & Manufacturing Company headquarters. *Nyla Vollmer.*

Coal Company in conjunction with the Continental Coal Company and reorganized it as the New York Coal Company. They operated five large coal mines at Chauncey, Luhrig, Lick Run and Tropic through the affiliate Manhattan Coal Company. By then, he had moved to Columbus to enjoy his wealth.

Among Poston's other business interests was the brick and clay industry. For many years, he owned and operated brick and fire proofing plants at Nelsonville, the Diamond, Logan, Zanesville and Portsmouth. In contrast to many mine owners, he was interested in the development of the surface lands. At his direction, his company promoted the development of the land for farming and grazing. He fenced in several thousand acres of hill lands for grazing and river bottomlands for cultivation and tillage. He was particularly proud of the one-hundred-acre orchard he planted in Waterloo Township, Athens County.[24]

Although Nelsonville received the lion's share of the attention until after the Civil War, three Newark businessmen—Dille, Brice and Moore—had laid out the town of Pattonsville ( named after the pioneering Patton family) on the canal at Lock 17 around 1833.[25] Here they operated several coal mines and sandstone quarries, but Pattonsville failed to prosper. In 1851 or so, Peter Hayden bought a controlling interest in the operation, planning to mine the coal and ship it to Columbus for use in his various manufactories. Soon, the village of Haydenville began to spring up. As it did, Hayden began to make plans to establish a model community—an "ideal town"—to house his workers.

About 1856, Dille et al. purchased a hot-blast charcoal furnace from Hanging Rock, not far from Ironton.[26] After dismantling it, they had it shipped up the canal to a spot near Lock 17 and renamed it Hocking Furnace. It was also acquired by Hayden, who placed his nephew, Halleck Hayden, in charge.

While mining coal and iron in the area, Hayden discovered deep-bedded fire clays that were to prove even more important to Haydenville's future. In order to capitalize on them, he constructed a clay products plant— Haydenville Mining & Manufacturing Company—close to the railroad. Clay dug from pits along the riverbank were carted through a tunnel to the factory. Because Nelsonville predated the first coal mines, there was little need for the mine operators to establish a town or construct housing. Haydenville, on the other hand, was too far removed from existing towns, so one had to be built to accommodate the required workforce and its needs.

Unlike most company towns, Hayden built his mostly out of brick rather than wood, and many of the buildings still stand. The vitrified bricks, blocks, tiles, pipes and fittings produced by his company were used to build the workers' homes, as well as numerous other buildings in the town, such as the church, post office, school and general store. As the Hocking Valley coal fields were further developed, additional company towns would spring

up throughout the valley in even more remote locations, with the railroads leading the charge.

Although he had initially been lured to the area by the coal, Hayden eventually abandoned the idea of mining his own. Given the profusion of coal mines already in the region, he relied on them to provide fuel for his furnace. With the arrival of the railroad, coal was delivered by the carload via a siding that ran into the tile plant. In all likelihood, Hayden would have been content to remain in Ohio for the rest of his life. But following the death of his wife, Alice, in 1865, he relocated to New York City, settling into a Manhattan mansion with his second wife, Sarah Barnard Leverett. When he passed away at the age of eighty-two in 1888, his remains were returned to Columbus for burial at Green Lawn Cemetery, which was to become the final resting place for many other coal barons. (See Appendix I: Workers and Bosses.)

# CROSSTIES AND TYCOONS

*[I]t is more than a mere poetic comparison when one conceives of the coal as the food of the locomotive and the combustion as the basis for its life.*
—Carl Friedrich Wilhelm Ludwig, Die Gartenlaube *(1870)*

There had been talk of building a railroad in Ohio during the 1820s. But it wasn't until 1836—when the Erie & Kalamazoo Railroad commenced operations between Toledo and Adrian, Michigan—that there was anything to show for it. By 1847, interest in bringing a railroad to Columbus had persuaded a group of speculators to form the Central Ohio Railroad Company. The plan was to run a line through Newark and Zanesville to the Ohio River. After surveying the route, an engineer recommended crossing the Ohio River at Parkersburg, but a charter with the State of Virginia required that the railroad be routed to the north, through Wheeling. Had the engineer's recommendation been followed, not only would the railroad have been cheaper to build, but the coal trade with the Hocking Valley would also have been initiated twenty years earlier. Instead, the resulting enterprise experienced considerable financial hardship during its life, temporarily cooling the ardor for laying additional track.

Having heard of a plan to build a railroad from Xenia to Columbus, Pearl Kimball came from Boston, Massachusetts, during the summer of 1848 to take a closer look. He wanted to see if his idea to construct railroad cars in Columbus was a workable one. Making the acquaintance of Joseph Ridgeway (Senior and Junior), who were already manufacturing plows and

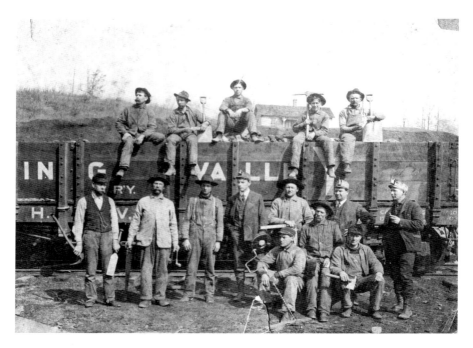

A work crew on the Hocking Valley Railway. *Nyla Vollmer.*

other implements at their foundry, he determined they would also be able to produce wheels, axles and much of the machinery for car building. It wasn't long before Kimball had signed a contract to deliver some sixty railway cars of various types for the Columbus & Xenia Railroad Company.

Operating as Ridgeways & Kimball, the businessmen located their car shops and yards on four acres of land two hundred yards west of the Scioto River, north of the National Road (later West Broad Street).[27] The main building was 250 feet long, 50 feet wide and two stories high. There was also a blacksmith shop 50 feet long, 30 feet wide and one story high. For constructing his cars, Kimball purchased white oak and other timber from W.F. Brick, located just outside Columbus in what later became Grove City. He bought wrought iron from Peter Hayden. To meet his own needs and those of his other businesses, Hayden built the Birmingham Works, an enormous rolling mill, on the east bank of the Scioto River at State Street. The mill was capable of producing eight tons of bar iron and three tons of rod each day.

Returning to Boston, Kimball recruited builders and mechanics to relocate to Columbus to work for his company. Unfortunately, many arrived

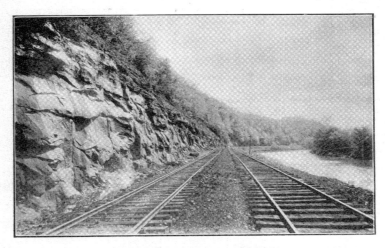

The Hocking Valley Railway parallels the Hocking River. *Authors' collection.*

in August 1849, just as a cholera epidemic was sweeping the community. Not a few died, and others fled the city, planning to remain away until cold weather set in. Nearly all business activity came to a standstill. As a result, the car shops remained unfinished, and the men began working in temporary quarters. It was a primitive operation at best. By the time the disease abated in mid-September, the death count was 162, not counting 116 inmates of the Ohio Penitentiary.

The building of railroad cars had barely gotten underway when the company suffered another setback: the unexpected death of Joseph Ridgeway Jr. in 1850. For the next four years, the uncle continued the foundry alone before selling out to Hayden (while Kimball would take complete control of the railroad car business in 1857). To fuel his wide-ranging empire, Hayden required copious amounts of coal, so he purchased some three thousand acres of land in Green Township, west of Nelsonville at Hocking Furnace.

As of 1858, Columbus had four partially completed railroads and as many others in the planning stages. However, the problems that pioneer railroaders had encountered discouraged others from investing in such pipe dreams. Nevertheless, by 1863, interest in constructing a Hocking Valley railway line once again was being discussed in the local newspapers, prompted by the high price commanded for coal owing to the difficulty of transporting it to Columbus by canal.

Enter Milbury Miller Greene. Born in Lewiston Falls, Maine, in 1831, Greene came to Ohio while in the employ of French, Dodge & Company to assist in building the Marietta & Cincinnati Railroad. Although it had been founded in 1845, the railroad was still under construction a dozen years later. After that project was completed, Greene remained behind to operate a saltworks he had purchased in southern Ohio at Salina (originally platted as Tyler), seven miles north of Athens. He soon began to conceive of building a railroad from the Hocking Valley to Columbus as a vehicle for transporting his salt to market.

On April 14, 1864, William P. Cutler, John Mills, Douglas Putnam, Eliakim Hastings Moore and Greene, who was a prime mover behind the initiative, formed the Mineral Railroad Company with $1.5 million in capital stock. Half of the stock had been personally solicited by Greene. The proposed railroad would plunge into the heart of the Hocking Valley, connecting Athens to Columbus. It took nearly another two years for the survey to be completed. Columbus would be reached by two separate routes: one southern and one northern. The latter connected with the Central Ohio

Railway, while the former provided a shorter (by thirty-two miles) route from Baltimore to Columbus.

Greene put together the financing to extend the railroad southward from Columbus to Nelsonville in 1869. When he failed to find backers in southern Ohio, he went to Columbus, where he was able to interest some of the city's wealthiest citizens, including Peter Hayden and W.B. Brooks. They were not interested in salt but rather in the coal fields. At a meeting on December 19, 1866, Hayden, Brooks, George M. Parsons, William Dennison, Benjamin W. Smith, William G. Deshler, Theodore Comstock, Isaac Eberly (all of Columbus), D. Talmadge (Lancaster), J.C. Garrett (Logan), William P. Cutler (Marietta), E.H. Moore and Greene (both of Athens, although Greene would soon move to Columbus) were elected directors.

Five months later, on May 2, 1867, with the preliminary survey completed, the name was changed to the Columbus & Hocking Valley Railroad Company, with Hayden as president and Greene as vice-president. Twenty days after that, a contract was finalized with Dodge, Case & Company to construct the first leg—from Columbus to Lancaster—within eighteen months. Greene also directed the construction of spurs to the nearby coal fields while founding two additional railroad companies: the Columbus & Toledo, running up to Lake Erie, and the Ohio & West Virginia, which ran down to the Ohio River.[28]

After the Civil War, manufacturing in the United States underwent a dramatic shift from manual labor to machines. This was accompanied by the development of a nationwide railway system. Until then, most Ohio railroads operated entirely within the state borders. Three separate railroads competed for land and mineral rights in the Hocking Valley, scrambling to lay rails, sink mine shafts and open iron furnaces. Investors were particularly drawn to the "Great Vein," a fourteen-foot-thick layer of bituminous coal that underlay southern Perry County. Spurred on by the Industrial Revolution, the demand for coal seemed insatiable.

With the incursion of the railroads deep into the state, the market for Ohio coal exploded. By 1869, the Columbus & Hocking Valley Railroad had reached Nelsonville. Coal could be transported to Columbus in just seven hours, while it had required up to two weeks by canal. Within a few years, a journalist for the *Hocking County Sentinel* wrote, "Our valley smiles as it never did before, and laughs all over, when the cars come murmuring through cut and curve with their long line of heavy loads of black diamonds."[29] The massive exploitation of the Hocking Valley coal fields went into overdrive.

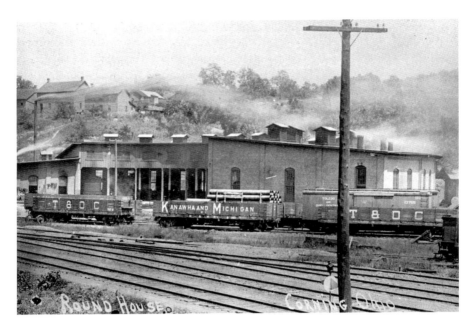

The roundhouse at Corning was constructed just south of town. *Bruce Warner.*

On January 20, 1869, regular passenger service was initiated between the two cities. Then, on August 17, 1869, the first freight train arrived in Columbus from Nelsonville, carrying 22 carloads of coal from the mines of Brooks and Houston. A small cannon on board was fired at various points on the line to serve notice that the train was arriving. When the first passenger train made a trip from Columbus to Lancaster on July 23, 1870, Smith, Deshler, Eberly and Brooks were on board. On January 2 of the following year, the Straitsville Branch was put into service. By then, 250 carloads of coal a day were being produced, and the railroad's investors were making money hand over fist.

In 1874, Greene succeeded Smith as president of the railroad. Between 1869 and 1877, the main line through Nelsonville to Athens was completed, as well as branches to Straitsville, Sunday Creek, Snow Fork, Monday Creek, Greendale, Orbiston and Sand Run. The opening up of the coal fields increased the value of the stock more than 50 percent above par. Business was thriving, both in Columbus and Hocking Valley.

Meetings had been held to discuss establishing a railroad from Columbus to Toledo in June and July 1867. Brooks, Comstock and Dennison, as well as Samuel Galloway, William A. Platt, William E. Ide and D.W. Day, represented Columbus interests, but nothing came of these talks. The

Columbus & Hocking Valley line had proved so profitable, however, that they quickly began thinking in terms of extending it to Toledo. On May 28, 1872, the Columbus & Toledo Railroad Company was incorporated. Within four years, it had contracted with the Pennsylvania Company for the joint use of the Toledo & Woodsville Railroad from Walbridge to Toledo, putting the last piece in place. On January 10, 1877, the line route from Columbus to Toledo was open for business.

An important development in the history of the Columbus & Hocking Valley railway was the replacement of the iron rails with steel. Steel was found to be seventeen times more durable than iron. In 1878, the entire road from Columbus to Athens and from Logan to New Straitsville now consisted of steel rails. Originally, the Ohio & West Virginia railway was incorporated on May 21, 1878, with the idea of building a line from the Hocking Valley community of Logan to Gallipolis on the Ohio River. However, little progress was made until the Hocking Valley interests took control exactly a year later and amended the charter to extend the run to Pomeroy. In October 1880, it was opened to Gallipolis and, on New Year's Day, to Pomeroy.

On August 20, 1881, the Columbus & Hocking Valley Railroad Company was consolidated with the Columbus & Toledo and the Ohio & West Virginia Railway Companies under the name of Columbus, Hocking Valley & Toledo Railway Company. Although this greatly expanded the railroad's reach and made it one of the most valuable lines in the state, it also increased its indebtedness. Greene continued as president of the combined railroads for another five years. On February 28, 1897, it went into receivership by order of the United States Circuit Court for the Southern District of Ohio. Retiring from the railroad in 1886 due to ill health, Greene died four days short of a year later, no doubt satisfied with what he had accomplished.

The relationship between the railroads and the coal mines was often an incestuous one, with many of the owners invested in both. As a result, railroads became a major bone of contention in mining disputes, and it was not uncommon for striking coal miners to vent their wrath against railroad property, from trains to bridges. But train wrecks were a fairly common occurrence anyway, without any outside interference, as the technology outraced man's ability to adequately control it.

No town in the Hocking Valley benefited more from its location on the railroad than Corning. It owed its very existence to the arrival of the Ohio Central Railroad in 1879 from the north. Not long afterward, the Kanawha & Michigan Railroad from the south connected with the Toledo & Ohio Central. Then, in 1890, the Zanesville & Western Railroad came in from

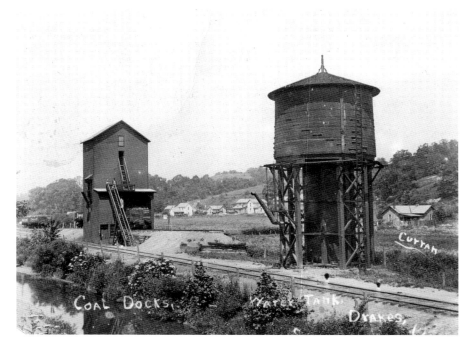

Coal dock and water tank at Drakes (or Drakes Station). *William E. Dunlap.*

the northeast, continuing westward. Lying in the crosshairs of one railroad running east–west and another north–south, Corning was transformed into a major railroad hub. During the first half of the twentieth century, its economy was more dependent on the railroads than coal. The high school's sports teams were called the Railroaders. Much of the town was given over to the railroads, with a roundhouse containing a giant turntable, two depots, a freight station, a couple of signal towers and numerous other buildings. But this, too, would pass.

# MOVERS AND SHAKERS

*The rich people not only had all the money, they had all the chance to get more;
they had all the knowledge and the power, and so the poor man was down, and he
had to stay down.*

—*Upton Sinclair,* The Jungle *(1906)*

The prophet of the Hocking Valley coal fields, if anyone deserves the title, was Colonel James H. Taylor. Born in Perry County in 1825, he came from a line of soldiers on his father's side and Simon Kenton, the frontiersman, on his mother's. Following service in the Civil War, Taylor spent the years 1865 to 1868 traveling from farm to farm, "prospecting." He carried with him an old carpetbag in which he chucked specimens of coal and iron ore he dug up, while informing many an incredulous farmer that a valuable vein of coal ran beneath his land. According to Clement L. Martzolff's *History of Perry County, Ohio*, Taylor "was looked upon as a sort of lunatic—but harmless."

Once he had confirmed his belief that there was coal underlying much of Perry County, Colonel Taylor began penning a series of articles for newspapers in Columbus, Cincinnati and New York. Unlike the farmers, many readers of Taylor's articles were intrigued and sought to capitalize on this knowledge. "Within ten years the population of the county had doubled," largely due to Taylor's efforts. "Shawnee, Corning, Straitsville, and other villages sprang into existence. Furnaces were erected. Mines were opened. Railroads were built."[30] And not a few of Taylor's readers became

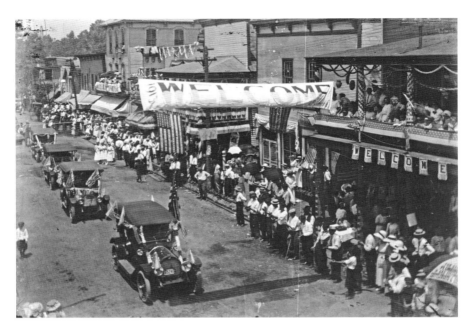

The New Straitsville Fourth of July Parade. *Wesley Tharp.*

coal barons and captains of industry. Taylor, though, was not one of them. Despite owning 125,000 acres of mineral-rich land in Perry County, he and his partners lost it all in the Panic of 1873.[31]

Long before Colonel Taylor invited the world to come to Perry County, the Strait brothers, Jacob and Isaac, laid out the village of Straitsville in 1835. During its early years, the only things Straitsville had to recommend it were a tavern, a few stores and loads of fertile farmland in the surroundings hills. But that was enough to make it prosperous. Add an active produce market, a few shops and a racecourse on one of the outlying ridges and Straitsville wasn't a half bad place to live. During the first three years of the Civil War, it became a recruiting station, and Union soldiers paraded in the street, practicing their drills. Although the brothers' name would survive, Straitsville wouldn't. And John Douglas Martin was the reason.

Born in Greencastle, Ohio, in 1819, Martin moved to Lancaster, where he set up shop as an attorney. He also engaged in banking—Martin & Company—and was an early stockholder in the Mineral Railroad Company. In 1869, at the age of fifty, he formed the Straitsville Mining Company on several hundred acres of land purchased from Joseph and Almyra Woodruff, about one mile from Straitsville at the proposed terminus of the railroad's

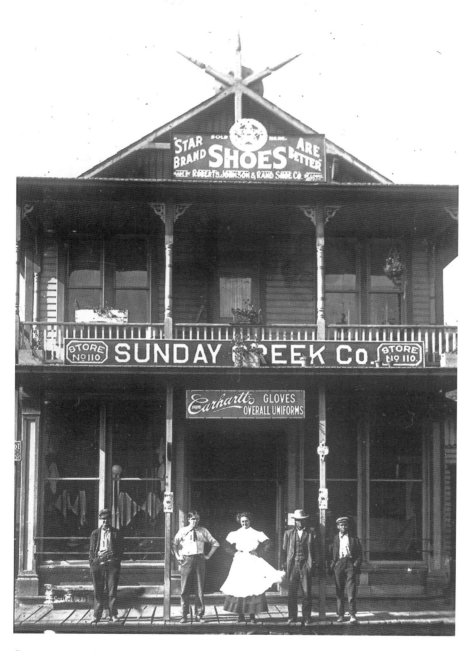

Company stores in rural areas were generally built of wood. *Bruce Warner.*

Straitsville Branch. The following year, he platted New Straitsville, began selling lots and opened the company's first mine.[32]

Located atop a massive coal bench, New Straitsville was the epitome of a "boomtown." Within a decade, it had four thousand citizens, most of British descent. In time, three furnaces would be putting out pig iron as well. The New Columbus Clay and Terra Cotta Company opened to take advantage of the valuable clay deposits. And eventually, more than one hundred oil wells would be drilled.

During the period from the coming of the railroad to the turn of the century, the population of New Straitsville grew fourfold. Despite the fact that hundreds of thousands of tons of coal were shipped out of its mines, the miners could rarely provide a good life for their families. The uncertainties in the demand for coal meant that they often lived on credit—when they could get it. In a good year, a miner might work ten months—in a bad year, three. Those who had families could not easily pull up stakes and move to where there was more work.

The labor movement was born in New Straitsville, and it was a union town to the bone. After the initial wave of American-born workers and experienced miners from the British Isles, a second wave of Italians, Swedes, Germans, Hungarians and African Americans came to join them in the mines. However, these "foreigners" did not receive a friendly welcome. They were blamed for lowering wages and creating a surplus of workers. As for strikebreakers, the New Straitsville miners made little effort to conceal the animosity they bore them. Rumors persist of "scabs" purportedly slain and buried beneath slag heaps.

In 1871, a newly formed union flexed its muscles by striking over wages. They were out of work for forty-five days. When unusually warm weather reduced the demand for coal in 1873, miners found their wages and hours cut once more. The miners, in turn, called on the railroads to lower their fees to help the coal industry get through the slump. All of the Hocking Valley mines went on strike in April 1874, and violence erupted in New Straitsville. The mayor deputized "responsible" strikers to help keep order. John Martin acceded to some of the miners' demands, but W.B. McClung of the Straitsville Iron & Coal Company would not and imported African American laborers from West Virginia to work in his mines. Seven men were said to have been badly injured in a racially motivated attack.

In 1888, there were ten black residents of New Straitsville. A dozen years after that, there were none. Some had undoubtedly moved to Payne's Crossing, a small African American settlement that had appeared in the

1830s. Never incorporated, it was a haven for free blacks and runaway slaves who did not feel welcome elsewhere. Unfortunately, the mine owners aggravated racial prejudice when they used black miners as strikebreakers.

As the mine prospered, so did New Straitsville, while Straitsville, renamed Coal, faded into obscurity. Although New Straitsville wasn't a company town, the Martin family were heavily involved in it. Edwin S. Martin, the founder's son, would live there for fifty-one years. He was active in the local government, serving on the town council and the school board. He also donated a building to the town for use a library, and his wife was the volunteer librarian for forty-seven years. In a 1907 history of New Straitsville, Edwin Martin was deemed "Our Foremost Citizen."[33]

Shawnee, a few miles to the north, was almost New Straitsville's twin. Since 1814, pioneering families had been settling in Salt Lick Township, an area that was considered "rural" even by Perry County standards, most of them trying to make a go of it as farmers. However, they couldn't help but notice that there was an abundance of coal in the region, much of it close to the surface. Always on the lookout for the "next big thing," T.J. Davis, president of the Newark, Somerset & Straitsville Railroad, decided to extend his line to what would become Shawnee in 1872. Even before then, coal was being exported from the region by the likes of Conover & Hayden, the New York & Straitsville Coal & Iron Company and Samuel A. Dickey. In the years that followed, other mines and furnaces were constructed.

As miners and non-miners flocked to the region, Davis laid out the town of Shawnee, which would include the "suburbs" of New York Hollow, New England Hill, Scotch Hill and Welsh Hill. Each name reflected the origin of the residents. There were 156 lots platted on what had been Israel Gordon's farm. Lots eight and nine were sold to Anna O'Bear, and Gordon's home served as the town's first hotel, the O'Bear House. Anna became the sweetheart of Captain E.P. Abbot, who conducted the original survey. Later, the same lot was the site of the Tecumseh Theater. Towering four stories, the Tecumseh, with its I-beam construction, was considered a "skyscraper" in 1908 and remains the tallest building in the county.

Davis's investment did not disappoint. Shawnee grew like a grass fire. During the early years, the Newark & Straitsville Coal & Iron Company was instrumental in the town's development, making several additions to the original plat. At its peak, four newspapers served the vibrant community. Two separate railroads, with their own depots and telegraph lines, continued to bring more and more men hoping to find work. And find it they did at Newark Coal Company, New York & Straitsville Coal Company, Furnace

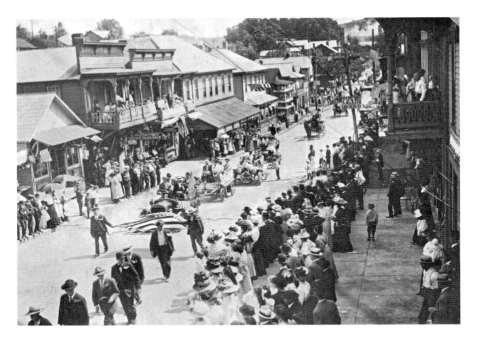

Fourth of July Parade in Shawnee showing the distinctive balconies. *Wesley Tharp.*

Coal Company, Shawnee Valley Coal & Iron Company, Upson Coal Company, Shawnee Valley Coal Company and the like.

The growth of the town was so rapid that by 1880 the population of Shawnee exceeded 2,770. The miners and their wives could shop at the New York Store, Upson's and Hamilton's, all company-owned stores (two of which used company scrip), or drink at one of nineteen saloons. For a time, there were eight churches, including the Methodist, Primitive Methodist, Church of God, Welsh Presbyterian, Welsh Congregational, Christian and Catholic. Lutherans held services in the school building, and the Jews met in the mayor's office.

In its early years, Shawnee was a rough-and-tumble place that attracted many "gentlemen"—those persons who made their livelihood by conning the miners out of their hard-earned wages. There was a minor breakout of lawlessness during the strike of 1874 when conflicts over one thing or another were inevitable. And then there were the usual murders and misadventures. A miner shot the woman who spurned him, as well as his rival for her affections, before killing himself. A dentist accidentally gave a female patient an overdose of bromide of chloral and fled town. During the Great Strike of 1884–85, miners were slaughtering the farmers' cattle for food.

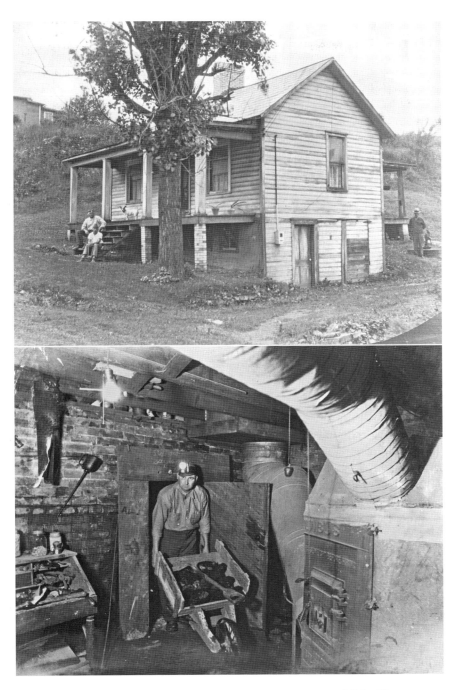

The Leaver residence at Shawnee had a coal mine in the basement. *Wesley Tharp.*

At one time, there were six mines operating in the vicinity of Shawnee (Upson's, Double X, Shawnee, Whippoorwill, Goslin and Barbours) and four blast furnaces (The Fanny, Double X and New York 1 and 2). Job-seekers from all over the country migrated to the remote little mining community, setting up housekeeping in every available structure. Many of the citizens of Shawnee did not own their homes but rather lived in hotels, boardinghouses and company houses located in such picturesquely named places as Whippoorwill Hollow, Upsonville, Shield's Hollow, New York Row, Smith Row and Manleyville.

Shawnee would come to have three lodge halls: International Knights of Labor Opera House, International Order of Red Men and the International Order of Oddfellows. The Knights of Labor Opera House, dating to 1881, may have been the first one ever built for that secretive organization. It was located on the second floor, while an experimental cooperative store operated by the miners was on the first. A man might belong to more than one lodge since they held their meetings on different nights.

Established in 1869, the Knights had attracted nearly 750,000 members by the time of the Great Hocking Valley Strike of 1884–85. The union welcomed all people, regardless of race, ethnicity or gender, who were "producers" of a physical product in the course of their work. In just the Buckeye State, the Knights had expanded from 800 members in 1880 to 17,000 by 1887.

By 1880, the population of Shawnee exceeded 2,770, and by 1891, it had reached 4,000 (including John Lilly, the lone African American resident of the community), making it a veritable "metropolis" (per county history). In April 1889, the Jeffrey Manufacturing Company carried out the first practical test of its electrical coal mining machine in the mines of the Shawnee & Iron Point Coal & Iron Company. This was to replace the compressed air machines, which had been in use for ten years. During the gubernatorial campaign of 1893, Lilly told then governor (soon-to-be president) William McKinley that he "held the Negro vote of Saltlick Township in his vest pocket."[34]

Although Shawnee's economy would be further diversified by the discovery of oil and clay deposits, it did not bounce back after the Great Depression. Like New Straitsville, it is a shadow of its former self. The boom was followed by a bust. It had gone from a town where everyone wanted to go to one where nobody wanted to be. When the mines closed, the economy died. Today, Shawnee is a semi-ghost town, with buildings crumbling faster than they can be saved.

There were settlers in the vicinity of Shawnee long before the town came into being. The villages of McCuneville and Hemlock predated it by decades, owing to the presence of the salt deposits and the industry that developed out of them. As early as 1855, a farmer purportedly had a coal mine for his personal needs. As others became aware of the great coal fields that underlay the region, it was just a matter of time before commercial mines would be developed and coal mining towns founded.

Never a very imposing place, Hemlock (the name came from a large hemlock tree that stood where the town was laid out) became a coal town with the arrival of the Columbus, Shawnee & Hocking Railroad in 1890. The company leased some property and sunk a large mine. The town was located in Saltlick Township, which has been organized about 1823. However, the Hazeltons and other settlers had begun arriving eight years before that. They were likely oblivious to the massive iron and coal deposits that underlay it but were attracted by the abundance of game—deer, bear, wild turkeys and other smaller game—that thrived there. The deer, especially, were easily ambushed, as they were drawn to the saltlick. By 1829, this was developed into a saltworks. The Hemlock Woolen Mill was already in operation when it changed ownership in 1871.

At the beginning of the twentieth century, six out of ten people in the United States lived in rural areas—rural being defined as 2,500 people or fewer. Places like Hemlock. Ten years after the railroad came to town, there were 581 residents, but by 1920, the population had dropped to 497. Today, Hemlock has an estimated population of 155, while Shawnee and New Straitsville have 645 and 713, respectively. Fewer than 2 out of 10 people in the nation live in rural areas, as the importance of the small town continues to decline. What Richard Davis had written of Camden, Ohio, applies to many of the Little Cities of Black Diamonds: it was "caught up in a slow but sure downward spiral, from which there is no escape. The town will not die, but neither will it flourish. A mood of quiet resignation seems to hover over the small valley in which it is located."[35]

# HEARTH AND STACK

*[T]he man who is…physically able to handle pig-iron and is sufficiently phlegmatic and stupid to choose this for his occupation is rarely able to comprehend the science of handling pig-iron.*
—*Frederick Winslow Taylor,* Hearings Before Special Committee of the House of Representatives *(1912)*

Ohio's iron industry developed by happenstance. Wherever a deposit of iron ore was stumbled upon, regardless of the quality, someone was apt to construct a charcoal-fired blast furnace. The earliest such furnace was built in Mahoning County on the banks of Yellow Creek by brothers Daniel and James Heaton in 1802–3. Called the Eaton-Hopewell Furnace (Daniel changed his name to Eaton after coming to Ohio), it was the first blast furnace west of the Alleghenies, but others would soon proliferate throughout the state. The father of William McKinley, future president of the United States, was associated with the iron furnaces in the region, possibly managing the Anna Furnace at Lowell, which was the first one in Ohio built specifically to use raw coal.

Blast furnaces appeared in China some two thousand years ago. It wasn't until sometime after AD 1100 that the technology began to turn up in Europe. The furnaces that appeared in Sweden, Switzerland and Germany were as inefficient as the earlier Chinese creations, but several important improvements were made by the time the technology reached the United States. And the Chinese had begun using coal by then. Had the Europeans

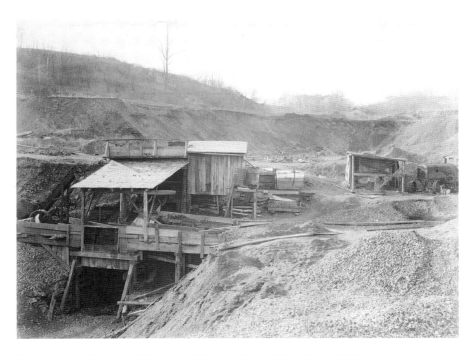

The old slag pile at Baird's Furnace. *Columbus Citizen/Citizen Journal Collection.*

done so, they might have saved more of their forests, although likely at the expense of increased pollution in their streams and rivers.

According to the *Report of the Geological Survey of Ohio*, published in 1884:

> *In the Hocking Valley region the iron industry dates from 1851, in which year Hocking furnace was built, which was followed by the Logan furnace in 1853, and by the Union furnace in 1855. These were all cold blast charcoal furnaces, and used the native block ores of the Hocking Valley.*

These charcoal furnaces were erected in areas that had trees, iron ore and a fire-resistant clay that was used to build the walls of the furnace. Originally, they were all cold-blast furnaces because the air was not preheated before being blown into them with a bellows. Within thirty years, the Hocking Valley iron industry was producing 116,000 tons of iron, helping to drive the development of the coal industry.

Samuel Baird has sometimes been credited with building the Hocking Furnace, but this is probably specious. A lifelong furnace man, Baird was a pioneer in the development of iron interests in the Hocking Valley. He had

worked a charcoal furnace at Logan, and this had familiarized him with the quality of ores available in the region. In 1859, he helped organize the Zanesville Furnace Company and had charge of it for fifteen years until failing health forced him to give it up. For two or three years, he lived in St. Paul, Minnesota, before coming to Columbus, where he superintended the building of an iron furnace in the northwest part of the city, making many business acquaintances in the process. To Baird goes the credit for recognizing the value of Hocking Valley coal in the iron-making process. He was drawn to the area by the belief that there was a fortune to be made there.

In partnership with William G. Deshler and General Samuel M. Thomas (both of Columbus), Baird built the first coal-fired blast furnace in the Hocking Valley in 1874 at a cost of $45,000. It was located three miles from the railroad line in the southeast part of Monday Creek Township, Perry County, to take advantage of an outcropping of coal and a nearby deposit of iron ore. A road had to be constructed so the iron could be hauled by oxen to the railroad.

The Baird furnace was forty-four feet high and eleven feet, eight inches in diameter at the bosh (the intermediate section between the hearth and the stack). In designing the furnace, Baird placed the stack against the hillside. A track led from where the coal was being mined fifty or one hundred feet away to the top of the stack. It commenced operation ("went into blast") in October of the following year. In just the first twelve months, the furnace realized a net profit of $25,000.

Because the furnaces were located in isolated communities, they were sometimes referred to as "plantations." All of the resources required for the production of iron—clay, limestone, timber, coal and iron ore—were close at hand. The product of the furnaces was termed "pig iron" because of its resemblance to a litter of piglets. A mold consisting of a central channel that branched off at right angles into individual ingots was formed in sand and then filled with molten iron. After it cooled, the ingots or "pigs" were broken off. When the iron-making resources were exhausted, the furnace would either be relocated or abandoned.

"[A]lthough much booted at, however, and ridiculed by furnace men generally, and characterized in advance on every hand as an absurd blunderer," Baird persevered, despite a great depression affecting the iron industry, and "proved a decided success both in making good iron and good money."[36] He soon had eighty-seven men working the furnace or supplying it, turning out sixteen tons of Number 1 foundry "Baird" iron daily. Quitting

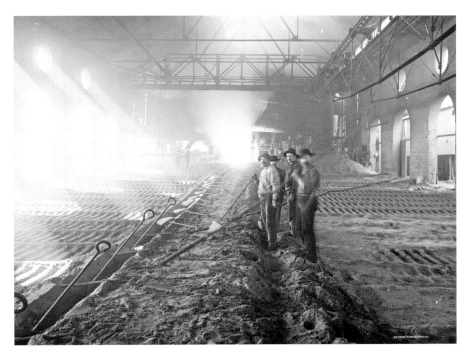

Casting pig iron at the Iroquois smelter in Chicago. *Library of Congress.*

Columbus, Baird had established his residence at Baird's Furnace when he suddenly passed away in 1877. He had been sick only briefly, and his death came as a shock to his friends.

The switch to coal was not the obvious choice it might seem. Because of the vast forest that covered Ohio, charcoal was close at hand, whereas coal had to be mined and transported. Furthermore, the high sulfur content of the coal was detrimental in the smelting process. But as the forests disappeared, the use of coal became essential. Just as wood was converted to charcoal, coal was converted to coke in order to rid it of its impurities. In time, coal-fired furnaces were built where deposits of iron ore and coal chanced to be in proximity. Three and a half tons of coal would produce a ton of pig iron.

In December 1876, a second furnace went into blast near Gore Station, Hocking County, three miles from Baird's Furnace. It had been erected by General Thomas in association with Colonel Solomon Churchill. Operated as the Thomas Iron Works, it was forty-seven feet high and twelve feet, six inches in diameter at the bosh. In every aspect, it was modeled after Baird's

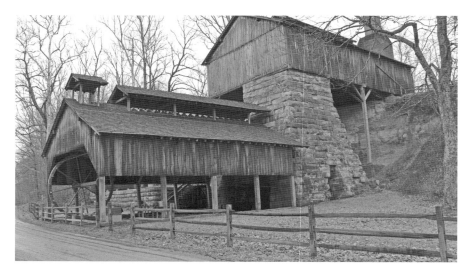

The reconstructed Buckeye Furnace in Jackson County. *Authors' collection.*

Furnace. Twenty-five men worked the furnace, sixteen dug the coal and sixty-five got out the ore and lime.

Thomas had been born in Lawrence County in 1840. Educated in Marietta, he worked as a clerk at the Keystone Iron Company until the outbreak of the Civil War in 1861. He served with such distinction in the Twenty-Seventh Ohio Volunteers that during his four years' service he was promoted to brevet brigadier general. Mustered out of the service in 1867, he applied himself to the coal and iron industries in the Hocking Valley and later served as president of several railroads. Thomas became famous for his "scoop of a few million dollars from the Vanderbilts with his Nickel Plate railway scheme."[37] He then retired to New York City to enjoy his wealth.

The son of Columbus banker David Deshler, Baird and Thomas's partner, William Green Deshler, inherited his father's financial empire. While he dabbled in different businesses, he was really more of a philanthropist. For example, he was responsible for turning East Broad Street into a tree-lined boulevard like the ones he had seen in Havana, Cuba. However, he would also become a founder of the Hocking Valley Railroad.

Eventually, competition from northern Alabama, where the iron ores were of a higher grade, reduced the demand for both Ohio iron and coal. In an effort to win back some of the market, the price of coal was reduced to fifty cents per ton. The Alabama smelters responded by cutting the price of their pig iron even further. As a result, Ohio furnaces looked to expand

their market westward into Indiana and Illinois. At the same time, the coal fields of Pennsylvania were sending their product to the same market, taking advantage of low railroad and steamer rates. In the end, the Great Strike would sound the death knell for the Hocking Valley furnaces, even as the northeastern part of the state was coming into its own.

Cleveland businessman John D. Rockefeller and others chose to locate their steel mills in Akron, Canton, Cleveland and Youngstown because of an abundance of coal and iron in that region, as well as its proximity to Lake Erie. This gave the businesses a decided edge when it came to transporting their products. As Rockefeller, a social Darwinist, purportedly once said while teaching Sunday school, "The growth of a large business is merely a survival of the fittest."[38] The Hocking Valley iron industry did not survive.

# Chapter 6

# BOOM AND BUST

*Most of the things one imagines in hell are there—heat, noise, confusion, darkness, foul air, and, above all, unbearably cramped space. Everything except the fire…*
*—George Orwell,* The Road to Wigan Pier *(1937)*

The railroads changed everything. As they pushed farther into the Hocking Valley, dozens of mining towns sprang up overnight with names both commonplace and exotic: Bessemer, Buchtel, Carbon Hill, Dicksonton, Drakes, Ferrara, Glouster, Jobs, Monday, Orbiston, Murray City, Rendville and Talleyho. They were scattered along the railroad tracks like lumps of coal that had tumbled off the hopper cars. By 1872, production of "black diamonds" in Ohio mines had reached 5 million tons per year. Fourteen years later, it would be twice that. If it were not for the high sulfur content of bituminous coal, which makes it less desirable, mining might have continued to expand throughout the twentieth century. Instead, prospective customers began using alternatives such as low-sulfur anthracite coal, natural gas and oil.

Organized on May 23, 1873, in Columbus, the Bessemer Coal & Furnace Company had great plans for the area where Snow Fork entered Monday Creek. With General Thomas Ewing of Lancaster as the company's president and Theodore Talmadge of Columbus as superintendent and general manager, they began to lay out a new town—Bessemer—that would be the most ambitious in the region. They proceeded to plat 1,025 lots with

The post office in Modoc, Athens County, operated for just five years. *Wesley Tharp.*

space for parks, an eighty-foot-wide main thoroughfare running east and west and other sixty-four-foot-wide streets paralleling it. The largest block was designated for businesses, while two sites were set apart for iron furnaces. All of this was in anticipation of the coming of the railroad. However, only four months later, the nation was plunged into a depression by the failure of one of its largest banks, Jay Cooke and Company. Immediately, all construction on the railroads stopped, and the sale of lots in Bessemer (which had been bringing prices as high as $500) dwindled down to nothing.

After the company was forced into bankruptcy, John R. Buchtel's Akron Iron Company swooped in to acquire the assets and then sold off the proposed site of Bessemer to a Newark real estate company, Birkey & Lee. According to the dean of Hocking Valley historians, Ivan M. Tribe, they had hopes that it would become "the seat of AN EMPIRE OF INDUSTRY," riding on the coattails of Akron Iron. However, the town of Buchtel was established closer to the iron furnace, making Bessemer redundant.[39] This financial reversal led Captain E.P. Abbot, real estate agent for Birkey & Lee, to commit suicide. Although the Panic of 1873 temporarily brought

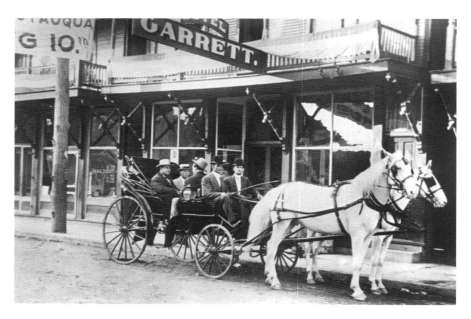

A coal mining center, Crooksville was better known for pottery. *Wesley Tharp.*

all work on the rail lines to a halt, three years later things were humming once again.

John Buchtel's initial success had come as president of the Akron-based Buckeye Mower & Reaper Company, which had broken away from Ball, Aultman & Company, a Canton farm machinery manufacturer. But in 1877, he turned his attention to the Akron Iron Company, which was founded to provide iron for the manufacturing operation. Buchtel later recalled, "The Akron Iron Company owned a furnace in Akron which they wanted to move somewhere where they could get to use it to a profit. I was sent down to the Hocking Valley, and I selected a piece of land…and moved the furnace there and was the General Manager of the Akron Iron Company business until the spring of 1883."[40]

As early as December 1877, a community of some thirty-five buildings and seventy families had already sprung up around the furnace and the adjacent coal mining operation. When the post office opened for business on May 5, 1879, the town officially became known as Buchtel, following the not particularly uncommon practice of naming a company town after a corporate executive. Just six years after the company's founding, Buchtel already comprised 184 company houses, a five-hundred-seat opera house, two physicians, an Odd Fellows Lodge, a Knights of Pythias Lodge

(relocated from Nelsonville) and the largest mercantile store in the region. Two churches—one Roman Catholic and the other Methodist Episcopal—were in the process of being erected on land donated by John Buchtel. He also paid for the construction of a schoolhouse at a cost of $3,000. At about this same time, three different Knights of Labor Assemblies were organized, one entirely German-speaking.

Described as a man of high integrity, Buchtel purportedly charged fair prices at his company store and attempted to keep alcoholic beverages out of the community. Although he did not ban them, he believed that excessive drinking "had more than anything else to do with the poverty in the valley—this excessive use of beer and whiskey."[41] Of course, some of the town's citizens resented such a paternalistic hand in their day-to-day affairs. And their regard for Buchtel was further eroded when many workers and their families were evicted from their homes during the Great Strike. However, they were more likely to blame the Syndicate, which came about when the Akron Iron Company merged with the Columbus & Hocking Coal & Iron Company a year earlier, relegating Buchtel to the vice-presidency.

Following the strike, Buchtel started a policy of allowing the coal miners to purchase the company houses they had been occupying. He also discontinued the use of company "scrip" in lieu of cash. Despite his involvement in the community that bears his name, Buchtel's fame as a philanthropist owes more to his contributions to his adopted hometown of Akron, most notably the founding of Buchtel College, which eventually became the University of Akron. Ironically, Buchtel was a poorly educated man who, purportedly, could barely write his name at the age of twenty-one.

The town of Buchtel continued to experience hard times. The Panic of 1893 resulted in the closing of the iron furnace. Four years later, a state census of "miners needing relief" found that roughly 80 percent of the town's citizens were destitute. However, by 1900, the coal mines were all operating again, and there was not an unoccupied house in all of Buchtel. Incorporated that same year, the town flourished throughout the next decade, reaching a peak population of 1,180. It survived until the Great Depression.

Murray Brown's ambitions were similar to John Buchtel's, but his reach exceeded his grasp. Perhaps as early as 1873, he set about platting the town that bears his name, Murray City, four miles to the north of Buchtel. In anticipation of the miners and their families who would be coming to work in the mines he would open, he built a large hotel. However, failing to obtain the additional funding he needed to fulfill his dream, he went bankrupt and

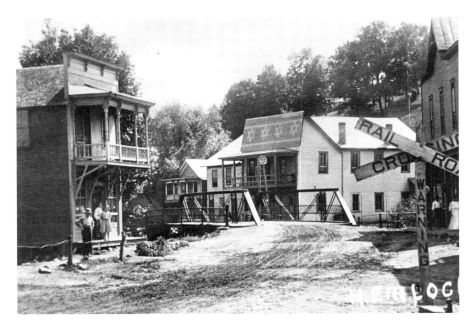

Main Street in Hemlock, a typical boomtown. *Wesley Tharp.*

was forced to abandon his project. Eventually, his hotel was destroyed by fire. Some ten years later, the Greendale Company opened Mine Number 7, ushering in an era of prosperity. The boom that Brown had anticipated finally took place. Murray City began to rival other mining communities in the Hocking Valley, but its growth was stifled by the fact that it was a company town.

During the Great Strike, Murray City suffered disproportionately when its mine was shut down and the miners were forced to move elsewhere to find work. This led to overcrowding at Buchtel and other mines, which had agreed to accommodate as many workers as they could. Consequently, none of the miners worked full time. Finally, in 1891, Murray City was incorporated and began attracting outside businesses and additional settlers who wanted to make a home there. Gradually, the towns' rowdier citizens were displaced by the law-abiding, church-going element. With new housing additions popping up, the town grew to a population of two thousand in 1907, overlapping Hocking and Athens Counties. Four trains daily carried passengers to Nelsonville, ten miles distant on the Hocking Valley Railway.

Originally, the residents of Murray City were primarily Americans and immigrants from eastern Europe, but the opening of the mines attracted

southern Europeans as well. Still, the Americans, Scotch, Irish and English were in the majority. During the Great Strike, the citizens of Murray City suffered greatly, but they remained steadfast union men. Once home to the largest coal mine in the world, its population has since fallen to below five hundred.

There is still a Moxahala, six miles southeast of New Lexington, the county seat, but it is only a shadow of its former self. Located in southern Perry County, "Moxie" (as it is more familiarly known) was laid out in 1873 by A.S. Biddison and surveyed by William Rich. The Biddisons were some of the original settlers and had built a sawmill there in 1842. The town took its name from a nearby creek and supposedly means "elk horn." Both Biddison and Rich were commemorated by streets named after them. At one time, Moxie had two hotels, five stores, a blast furnace and a population of five hundred.

In 1875, Moxahala became a stop on the Toledo & Ohio Central Railroad's "Mine Run," which linked it to New Lexington and, a few years later, Corning. Those who came to the community were pleased to find that the area had a four-foot vein of coal and a seven-foot vein of iron ore, as well as the second-best fire clay deposits in the state. The original blast furnace was owned and operated by the Carnegie Steel Company. However, a new one went into blast on January 1, 1878. Owned by King, Gilbert & Warner, its average output was forty-eight tons of iron per day and employed fifty people. The workers lived in company houses on "Red Row" (they were all red in color).[42] Two years later, a pottery was constructed that employed ten. Its wares were entered in competition at the Ohio State Fair and won the top prize in each category.

When the Moxahala furnace was disassembled and moved to Columbus in 1897, many of the company's employees relocated to Columbus to hold on to their jobs. This could have been the town's death blow, but in 1904, the Chapman Mine opened one mile west of town. Employing five hundred workers, the company built two hundred houses and also occupied every available room in Moxahala. Yielding 2,500 tons of coal per day, the Chapman Mine was one of the top producers in the state during this era.

With the revival of Moxie's fortunes, other businesses were attracted to the town. In 1905, two men named Mussler and Hecock came from Columbus to build a brick plant. They had everything they needed: fire clay, coal, water (courtesy of a reservoir built for the furnace)—everything but money, that is. So they sold stock. However, after the men started constructing the plant and even sold a few bricks, they skedaddled and the company folded. Still,

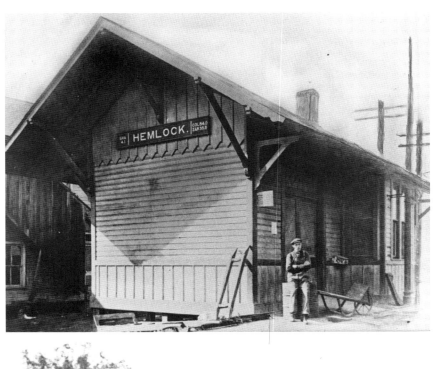

Mr. Fitzer remodeled the former Hemlock Train Depot into a house. *Wesley Tharp.*

the clay mining continued and was shipped to Shawnee via the railroad for use by the Claycraft Company.

Moxahala had everything most people in the era of small towns needed: stores, saloons, churches, craft shops, a post office, a dance hall, a theater and the Knights of Pythias Lodge Hall. When the Chapman Mine closed in 1914, the town barely noticed because it was replaced by the Kaiser, Ohio Central and White Elm Mines. A gas company also formed, led by two local merchants, Carrol and Kiener. It continued into the 1950s.

However, the mines began to close after World War I, and many residents of Moxahala left to seek work elsewhere. This caused other businesses to fail. The only jobs left were at the sawmill, the railroad or farming. With the outbreak of World War II, the Ohio Central Mine was reopened by the Brownfield Mining Company. When the war ended, so did the operation of the mine. By 1953, the population of Moxahala was half of what it had been eighty years earlier.

In 1965, the Peabody Coal Company began strip-mining the countryside in the vicinity of Moxahala, robbing the rolling hillsides of much of their natural beauty. When the company obtained all the coal it could that way, it opened the Sunnyhill Mine, which attracted many mineworkers from outside the community. Whatever the future may hold for the town, it is unlikely that coal will figure into it.

The importance of salt to the early settlement of Ohio cannot be overstated. In the days before refrigeration, salt was essential for the preservation of meat and fish. Contracts and treaties were made that sometimes called for payment in salt. Because of the presence of salt deposits, the federal government retained control of four thousand acres of Ohio lands in Delaware and Jackson Counties until 1824, prohibiting their sale. Some of the state's earliest communities were founded around saltworks. It was the first mineral commercially exploited.

In 1839, businessman Elihu Chauncey laid out the village of Chauncey (pronounced "chancey") in Athens County at the site of a natural salt springs, about nine miles southeast of Nelsonville. It was across the Hockhocking River from Salina, where M.M. Greene & Company operated a pioneering saltworks.

As the 1883 *History of the Hocking Valley* noted:

> *Chauncey is situated on a level plot of ground forming a tongue of land*
> *between the mouth of the Sunday Creek and the Hocking. It has been*
> *a town of considerable trade, especially during those years of the active*

*manufacture of salt. Its location is favorable for the building up of a large town. There is ample building room for 20,000 inhabitants. Should some of our Eastern capitalists make Chauncey a center of operation on coal mining and iron making, there would soon gather into its locality a large and thriving population. It being situated on the Ohio Central and at the terminus of Sunday Creek Valley it would have the advantages of two valleys, Hocking and Sunday Creek.*

Evidently, there was at least one coal mine in the vicinity of Chauncey as early as 1845. According to newspaper accounts, a workman was riding up in one of the buckets with about ten or twelve bushels of coal when, just as he reached the top, the rope snapped. The man and coal fell about one hundred feet down the shaft. The bucket landed on another bucket, and both were "smashed to pieces." However, the worker miraculously escaped "without a vital injury, or a broken limb.[43] Unfortunately, nothing more is known about this early mining enterprise.

Although it would never come close to having 20,000 residents, Chauncey did have a "boom" period in about 1905 when the coal industry moved in and mines were opened. By 1921, there were at least a half-dozen mines around Chauncey, four of which were being operated by Columbus-based companies Big Bailey Mining Company and New York (formerly Manhattan) Coal Company. For the first half of the twentieth century, the town was riding high, but it has never had a population of much more than 1,000 people, peaking at 1,269 in 1930.

CHAPTER 7

# SYNDICATE AND EXCHANGE

*After one operator referred to the union as "a set of outlaws," I wanted to take him by*
*the seat of the breeches and nape of the neck and chuck him out the window.*
*—Theodore Roosevelt, "The President's Strike Conference" (1902)*

Generally speaking, competition is good for customers but bad for business. Coupled with a decline in demand, a rise in production costs or both, competition has caused many companies to fail, coal companies not excepted. Subsequent to the arrival of the railroads, competition among Hocking Valley mine operators became increasingly intense. In the early 1880s, rivals Samuel Thomas, Thaddeus Longstreth, Walter Crafts and Solomon Churchill—all of Columbus—and John R. Buchtel of Akron came to the realization that they needed to change the way they dealt with one another if they were going to survive. Colonel Churchill is credited with having initially proposed that they pool their interests in a federation or joint holding company.[44]

Churchill was born in South Point, Ohio, in 1834 and lost his father eight months later. Armed with nothing more than a common school education, he went to work at the Keystone Furnace in Jackson County at the age of sixteen, rising to the position of manager nine years later. He was also employed at Logan Furnace in Hocking County before coming to Columbus in 1878 and entering the pig-iron business with Samuel Thomas in the firm of Churchill, Thomas & Company. After five years of battling for market share, Churchill decided that there had to be a better way. The other coal men agreed.

A trade postcard from the Ohio Coal Exchange. *Authors' collection.*

In what some termed the "event of the year," the Columbus & Hocking Valley Coal & Iron Company was officially organized early in 1883 with offices in the Deshler Block in downtown Columbus. Familiarly known as the Syndicate, it represented eighteen mines, five large blast furnaces, 570 houses, twelve stores and 444 coal cars. The total value of the enterprise was estimated at more than $84 million. Its purpose was twofold: to eliminate price wars among the mine owners and to present a unified front in dealing with unions.

General Thomas, who controlled the largest interests from his home in New York, was chosen as president. Born in 1840, also in South Point, Thomas originally went to work at the Keystone Iron Company in Jackson, where he first came under the influence of Mendal Churchill, but when the Civil War broke out, he enlisted as a second lieutenant. As part of the famed Ohio Brigade, he saw action in many prominent battles and engaged in the "organization of colored troops."[45] Following the Emancipation Proclamation, he was charged with helping the African American population along the Mississippi with the transition to freedom and citizenship.

By war's end, Thomas had risen to the rank of general. Returning to Ohio, he met with great success in every business endeavor into which he entered—iron, coal, finance and, especially, railroads. His friend and mentor, General Mendal Churchill, offered him a management position at the ironworks in Zanesville. In 1872, Governor William Dennison selected him to take charge of the building of blast furnaces and rolling mills in

Columbus. The development of these enterprises led to his interest in coal mining and railroad construction. In 1891, the demands of his business compelled Thomas to move from Columbus to New York City. In a span of nine years, he assembled one of the largest railroads in the country.

Solomon Churchill, Thomas's business partner, was installed as treasurer of the Columbus & Hocking Valley Coal & Iron Company, which was the equivalent of vice-president. The concern was incorporated with $5 million of capital, which he was charged with overseeing. Besides his involvement with the Syndicate, Churchill was director of the Ohio & Kanawha Railroad and president of the Columbus Rolling Mill Company.

The strength of the Syndicate was in the talents of its members. Thomas was chosen president owing to his success as a financier, as well as a dealer in coal and iron. He would focus on the big picture. The iron department— which operated the Gore, Wynona, Crafts, Basil and Buchtel Furnaces—was managed by Walter Crafts. A mining engineer from Newton, Massachusetts, Crafts had graduated from Rensselaer Polytechnic Institute and also studied at

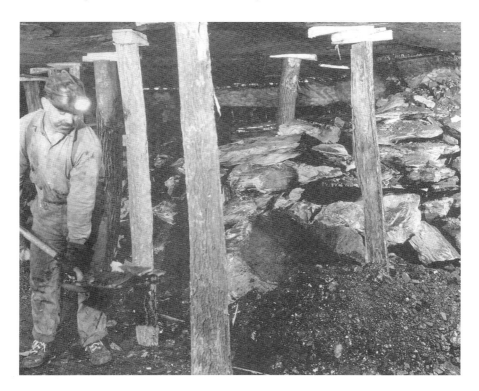

A miner shoveling "gob" (i.e., the loose waste in a mine). *Authors' collection.*

the Freiberg Mining School. In 1877, he settled in Columbus. Highly regarded for his engineering expertise, he served as president of the Crafts Iron Company before taking a position with the Syndicate. At the time of his death in 1896 at the age of fifty-six, Crafts was president of the Commercial National Bank of Columbus. He passed away while on a business trip to Pittsburgh.

The land department, consisting of 12,579 acres, was headed by John R. Buchtel, known for his skill in managing real estate. A wealthy industrialist from Akron, Buchtel had built one of the largest iron furnaces in the Hocking Valley at Bessemer (renamed Buchtel) in Athens County. Although Buchtel was a company town, John Buchtel was a "somewhat benevolent though paternalistic corporate leader" (to quote Ivan M. Tribe). He helped the miners build a school, provided land for a union hall and allowed non-company-owned businesses to operate in the community.

The coal department was presided over by Thaddeus Longstreth. A pioneer mine owner, Longstreth was the most successful coal baron in Columbus at the time he joined the Syndicate. His practical knowledge and skill in operating his own holdings made him a natural for assuming control of the mines. However, years of hard work and privation as a result of his war experiences and the effort of building his business began to tax his health. By the time he passed away in 1904, he had been retired for a number of years.

In the division of labor, Longstreth was given the lion's share of the work. The mines he commanded were grouped into three distinct divisions:

The STRAITSVILLE DIVISION, under Superintendent William Job, was situated in Perry County near New Straitsville: Number 3 (Rock Hill), Number 5 (Troy Mine), Number 7 (Central Mine), Number 9 (Job Mine), Number 11 (Straitsville), Number 33 (Old Mine) and Number 35 (Plummer Hill). Some six hundred men and boys worked underground in these mines.

Located in Hocking and Athens Counties, the MONDAY CREEK DIVISION consisted of the following mines: Number 15 (Sand Run Mine), Number 17 (Carbon Hill Mine), Number 19, Longstreth's (Monday Creek Mine) and Number 31 (Longstreth's Nelsonville Mine). Thomas Berry was in charge and maintained a workforce of 550 to 600 miners.

The SNOW FORK DIVISION, employing nearly seven hundred miners, was overseen by Thomas N. Black. The mines in this division, all located in Athens and Hocking Counties, were: Number 21 (Furnace Mine), Number

23 (East Hill Mine), Number 25 (Half Moon Mine), Number 27 (Buchtel Shaft) and Number 29 (Murray City Slope).

Henry D. Turney was appointed secretary of the Syndicate. Although his title might not have been impressive, he was an astute businessman in his

H. D. TURNEY.

H.D. Turney is driving the wagon for the Syndicate in this Billy Ireland cartoon. *Authors' collection.*

own right, being president of H.D. Turney & Company, a coal company, as well as the Congo Coal Mining Company, among other interests. Edmund A. Cole was the company's agent. Born in Barnesville, Ohio, Cole started out as a bookkeeper in the Columbus office of the Straitsville Central Coal Company in 1876 and was promoted after eighteen months to secretary and manager. When it was consolidated with the Columbus & Hocking Coal & Iron Company in 1882, he was appointed as assistant to the vice-president and, later, city agent. In 1892, he would leave to found the Hocking Valley Coal Company. After it was acquired by Sunday Creek Coal Company, he founded E.A. Cole & Company. For five years (1910–15), he served as president of Sunday Creek. He also co-founded with George Durell the Union Fork and Hoe Company. In addition to the officers noted here, there were three vice-presidents, each responsible for superintending one of three departments.

Individually, all were regarded as men of integrity and, arguably, compassion. However, their collective actions on behalf of the Syndicate were viewed as anything but from the standpoint of the mineworkers. In fact, the stress of the Great Strike, due to his heartfelt sympathy for the plight of the workers, may have brought about the stroke that disabled kindhearted John Buchtel in 1887. He would die five years later.

Adding to the miners' woes was another coalition of mine operators. In 1883, Consolidated Coal & Mining Company of Cincinnati, Nelsonville Coal & Coke Company, the Ohio Coal Company, W.B. Brooks & Son, Juniper Brothers & Laflin and Metcalf & Brewer—the owners of six Ohio mines—united as the Ohio Coal Exchange under the presidency of Levi R. Doty. Essentially a brokerage, the Ohio Coal Exchange took the lead in importing foreign miners into the Hocking Valley. "Captain" Doty to his friends, Levi Rinehart Doty was born in Springfield, Ohio, in 1847. After briefly attending Princeton University in 1867, he returned to his hometown, where he involved himself in the hardware manufacturing business. Four years later, he settled in Columbus and embarked on a career in coal production. Doty had a reputation as being an able and personable businessman.

Since the Syndicate and the Exchange operated in concert, the coal operators now had a virtual monopoly, and the workers were understandably alarmed. Some, but not all, realized that it behooved them to get organized as well if they were to have any say in their wage rates and working conditions. However, it would take a major event to galvanize them into action. In the spring of 1884, something did. The

country had been in a recession since 1882. Two years into it, a panic ensued when three major banks and ten thousand smaller ones failed. Once again, the bottom fell out of the coal market. Mines began to close, and hours were reduced.

Over the objections of John Buchtel and William Rend, the Syndicate asked the miners to accept a wage reduction from seventy to sixty cents per ton owing to the depressed economy and a drop in coal prices. When the miners rejected the cut in pay, the Syndicate and the Exchange responded by enacting a cut anyway, on Friday, June 20, 1884. On the following Monday, the miners went on strike.

CHAPTER 8

# MAN AND MACHINE

*One machine can do the work of fifty ordinary men. No machine can do the work of one extraordinary man.*

—*Elbert Hubbard,* The Philistine *(1903)*

In 1876, coal mining was a pick-and-shovel affair undertaken at risk of life and limb. As Robert Jeffrey recalled a century later, "The slowest part of the mining cycle was the undercutting, which required the miner to lie on his side for hours at a time digging with his pick a 6-inch cut, 4-feet deep, across a 10- to 20-foot-wide face."[46] No doubt many a miner was hastened to an early grave by this physically debilitating work. But then an enterprising fellow named Francis M. Lechner came up with the idea for an air-powered, chain-driven machine that would do the job quicker and easier.[47]

Gifted with a naïve mechanical genius, thirty-eight-year-old Lechner, a Columbus resident who hailed from Waynesburg, Ohio, built a wooden model of his coal cutter and exhibited it in a store window on High Street in the hope that it would attract the interest of a financier. And it did. Joseph Andrew Jeffrey, a banker with a minor interest in a coal mine in New Straitsville, immediately grasped the significance of Lechner's device. He, in turn, brought the invention to the attention of his employer, Francis C. Sessions, who replied, "I know nothing of machinery and engineering, but if you think the invention a good one, do as you see best and fit."[48]

Jeffrey was born in Clarksville, Ohio, in 1836. His father, James, had been a farmer in New Jersey, while his mother, Angeline Robinson, was the

A 1901 ad for the Jeffrey Manufacturing Company. *Authors' collection.*

daughter of a pioneering family in Warren County, Ohio. Following high school, Joseph took a job as a clerk in a general store. After various business experiences, he settled in Columbus, where he entered banking, first as a bookkeeper and, later, as a teller, a cashier and a manager. He helped to organize what became the Commercial National Bank in conjunction with Francis Sessions and his father-in-law, Orange Johnson.

Founded in a modest, one-room workshop on July 19, 1877, with a capital stock of $50,000, the Lechner Mining Machine Company set about manufacturing its "novel apparatus for cutting coal."[49] It was the start of a revolution. The same month, its very first "cutter bar breast machine" was delivered to the Central Mining Company in New Straitsville, Perry County, for testing. It immediately broke down. After the company's engineers tinkered with it awhile, it was discarded, and another one was constructed, heavier than the first. But it broke down as well.

According to Charles H. Welch, charged with demonstrating the coal cutter, "I think it's safe to say that Mr. Lechner had not less than fifty different men at various times working on his experimental machines…and every change made it worse instead of better. I think I'm also safe in saying that every ton of coal mined cost Mr. Jeffrey at least $100, and he began to

get discouraged."[50] But they finally got it working, and a year later, a second machine was installed at Longstreth's mine in Hocking County.

In 1880, Sessions resigned his position as the company's first president, having had his fill of the mining machine business, and Jeffrey succeeded him. But the challenges the men had encountered weren't just with the coal cutter. From the beginning, the mineworkers were opposed to the use of the machine. Lechner Mining had introduced the device at a time when union organizers were trying to gain a foothold. Even as they were attempting to organize strikes for better wages, market forces were pressuring the companies to lower production costs. The advent of the electric motor and the march toward mechanization injected another variable into the labor-management debate.

Although the purpose of the coal cutter was to ease their labors, the miners regarded it with a combination of fear and distrust, believing it would ultimately cost them their jobs. As a result, "Uncle Charlie" Welch carried a gun for self-protection and protection of the coal cutter, which he sometimes slept beside.[51] Many of the machines were deliberately vandalized.[52]

After a falling out, Lechner resigned as general manager in 1882. Jeffrey took on that responsibility, too. Three years later, the enterprise was in financial hot water, with all of its assets mortgaged to the bank. After buying out Lechner and some other minority shareholders in 1887, Jeffrey finally gave up his position at the Commercial Bank to devote full time to what was now called the Jeffrey Manufacturing Company. The success of the coal cutter created a demand for new types of machinery, such as conveyors, crushers and locomotives, to handle the greater volume of coal.

One of Jeffrey's employees, Henry B. Dierdorff, turned out to be a talented engineer who contributed greatly to the company's ultimate success. Born in Seville, Ohio, in 1851, Dierdorff pioneered in the field of electrically powered mining equipment. Among his thirty-five patents, the most popular was his design of a safe electrical lighting system for use underground. By the time of his retirement, he was in charge of Jeffrey's entire manufacturing operation.

In 1888, a year after Jeffrey took control, the company was starting to hit its stride. Moving to four acres on First Avenue, Jeffrey Manufacturing was fabricating all sorts of mining equipment, from coal cutters and underground electric locomotives to elevators and conveyors—much of it built on Dierdorff's patents. He is credited with having solved the problem of how to suppress the sparks generated by electrical motors by creating insulation that could be packed around them. As a result, he was able to

create the Congo Coal Cutter, the first safe electrical seam cutting tool for underground mining. The machine took its name from the fact that its initial success was in the Congo Mine.

While passing through Pittsburgh, Pennsylvania, railroader and coal operator Milbury Greene was interviewed on the topic of mine machinery:

> *A number of our miners are strongly opposed to the introduction of coal machinery. Many people predict this opposition will develop into violation of law and open riot, worse than the outbreak of two years ago. Notwithstanding this, we mean to put our machines into operation even though shot and shell will be needed to do it. We have a governor now who will fearlessly protect the rights of property. He will, whenever circumstances demand it, send sufficient troops into the valley to shoot the lawless element there who have made so much trouble of late. If a dozen or so of these men were shot it is certain that there would be peace for some time to come. This will be done if the destruction of property is again resorted to by the miners.*[53]

Jeffrey Manufacturing soon turned its attention to other kinds of mining equipment. In addition to coal cutters, the company made drills, pit car loaders and mine locomotives, as well as tipple machinery, such as car hauls, screens, picking tables, loading booms and ventilating fans. In 1879, the company began conducting business abroad with its first shipment of a mining machine to Scotland. Among Jeffrey's other interests were the presidency of the Ohio Malleable Iron Company and vice-presidency of the Citizens Trust & Savings Bank. As demanded for its products increased, the plant grew to encompass some thirty-six acres (some sources say forty-eight) and nearly 1 million square feet of floor space along North Fourth Street—the largest industrial plant in Columbus—employing five thousand or more people in its heyday.

Three years after he was hired in 1884, Dierdorff was promoted to general superintendent, holding the position until 1911. The company soon began building locomotives. The first one was shipped to the Hull Coal Company at Shawnee and was still in operation twenty years later. Among the others who deserve credit for the company's success were Pennsylvania-born Otto R. Ehret and Washington, D.C.–based patent attorney Henry H. Bliss. The locomotive had been conceived by Dierdorff and Bliss. The latter was the first to apply electricity to a mining machine for the purpose of motive power. Then, in 1893, Dierdorff oversaw the development of the first successful breast-type cutting machine that used a chain instead of a cutting bar. It proved to be more economical in terms of power usage and durability.

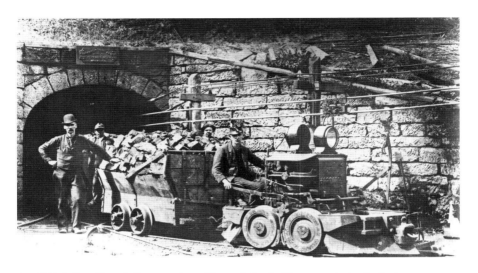

An 1888 Jeffrey Electric Locomotive at Upson Mine in Shawnee. *Authors' collection.*

During the next few years, competition picked up as Sullivan Machinery Company, Morgan-Gardner Electric Company, Link-Belt Company, Electric Mining Machine Company, Harrison and others all produced their own mining machinery. As it turned out, Lechner had sold a patent on a "single-chain cutter breast-machine mounted on a traveling frame" to the Electric Mining Machine. Another Columbus-based company, it subsequently sued Jeffrey Manufacturing for infringement of this patent. In its defense, Jeffrey claimed that Lechner had already assigned "thirteen twenty-fourths" interest in such patents on July 24, 1877, to Lechner Mining Machine Company, now known as Jeffrey Manufacturing Company and owned by Sessions and Jeffrey.

More than seventy-five patents were entered into evidence, attesting to how complicated and technical the arguments became. The patents were divided into the following classes or categories of coal machines then in production: "plows, power coal mining picks, coal-tunneling machines, coal mining machines having coal cutting cutter-saws, coal mining machines having coal-cutting cutter bars, coalmining machines having long wall-cutting chains, breast coal mining machines having two chains, coal-mining machines having reaper-bar cutters, single-chain breast hand coal-mining machines, and double chain breast mining disk-holder machines."[54] In the end, Jeffrey lost the case.

By 1915, Jeffrey Manufacturing's products had improved mine safety substantially while increasing daily output by miners from two tons in twelve hours to four tons in eight. At the same time, the company exhibited an

enlightened approach in the treatment of its own employees, inspired by the "Christian socialist" teachings of Dr. Washington Gladden, minister at First Congregational Church, where Joseph Jeffrey and his wife, Celia, were members. The company started one of the first on-site infirmaries in 1889 to treat victims of industrial accidents and opened a cooperative store in 1905. In 1912, an employee cafeteria was established, as was a building and loan association to help workers buy homes.

Around Columbus, positions at Jeffrey Manufacturing had a reputation for being "good jobs." By 1920, it was the third-oldest Columbus firm still engaged in business, behind the Kilbourne-Jacobs Company, which dated back to just after the Civil War, and Kinnear Manufacturing Company, which was founded in 1878.

Under Jeffrey's skilled management, the company's financial position continued to improve, reaching nearly $25 million by 1925—most of it from its non-mining interests. However, in 1928, a year before the stock market crash, Joseph Jeffrey died. Following his death, the company diversified further (acquiring Diamond Coal Cutter Company Limited of Wakefield, England, and Galion Iron Works and Manufacturing Company) and finally split into separate divisions. Luckily, Galion Iron Works was a maker of road rollers, graders and other road construction machines, and this enabled it to weather the Depression since the sharp decline in the demand for coal was partially offset by the steady demand for road-building equipment. Then, in 1936, Jeffrey Manufacturing introduced the 29-U universal cutting machine, which would become the industry workhorse for the next twelve years. With the demand for mining equipment continuing to decline, Jeffrey Manufacturing sold off the mining operation to Dresser Industries of Dallas, Texas, in 1974. Finally, the last mining machine manufactured in Columbus was shipped out the door in 1999, and the remaining thirty employees found themselves out of a job. The company now survives only as an investment trust for members of the Jeffrey family.

Jeffrey's machines were labor-saving devices, and that was both the good and the bad of them. They made the physical work of mining coal easier but also replaced the mineworkers, as they had feared. Those who weren't replaced became slaves to the machines. Just ask "Mother" Jones, the legendary union organizer. She would quote Aristotle, who had predicted that an inanimate object would someday do the work of a dozen men—a dozen of "Mother's boys." It was industrial bondage.

# WOMEN AND CHILDREN

*When a boy has been working for some time and begins to get round-shouldered,*
*his fellows say that "He's got his boy to carry round wherever he goes."*
—*John Spargo,* The Bitter Cry of Children *(1906)*

In 1934, Ida Mae Stull was deemed Ohio's only female coal miner. Despite a crippled leg, she had started working in the mines when she was six (or eight) years old, "carrying her daddy's lantern to light his way underground."[55] She never learned to read or write, but she prided herself on her stamina. In March 1934, James Berry, chief of the Ohio Division of Mines, banned Stull from working in the mines by citing an "old state law" that prohibited women from engaging in coal mining, taxi driving and other "dangerous occupations."[56] Stull, aged thirty-eight or so, filed an appeal with Governor George White, who granted her an exemption because she had dug the mine herself. Attorney General John Bricker opined that "women may work in coal mines in Ohio—providing they own the mine. However, they are not permitted to 'hire out' for a wage."[57]

According to Stull, other women already were, but they hid themselves when they learned the mine inspector was coming. She did not feel she was cut out to do anything else. As she told a newspaper reporter, "I've got no business baking cookies and mending clothes. I'm a coal miner."[58] She claimed she could load five tons of coal per day with a pick and shovel, as much as many men. However, she finally gave up mining in 1940 when her husband and partner, Harry, passed away.

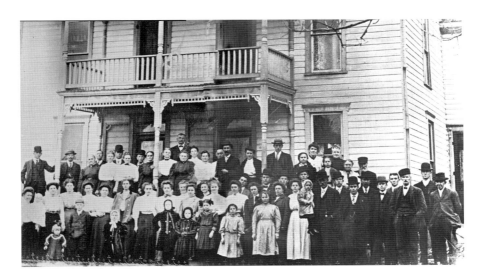

A church gathering at the William Tharp home in Hemlock's Bohemian Heights. *Wesley Tharp.*

England, Germany, Austria, France and other parts of Europe had a tradition of employing women in coal mines, where they were often used as "coal bearers" to carry the ore out of the mines. It is unlikely that many did so in the United States, however, unless they were masquerading as men, as an estimated four hundred women who fought in the Civil War did. A few may have been employed in office positions, but the majority remained at home, caring for their families, supporting their husbands and worrying about their safety. In addition to preparing meals and keeping the kids in line, the miner's wife fought a daily battle with the coal dust that permeated every nook and cranny. If they slept with the windows open, they would awake with a ring of soot around their nostrils. While performing her chores, the miner's wife would likely wear a dust cap over her hair. Periodically, she would have to wash the windows and beat the rugs. Dampened tea leaves were scattered over the floors to aid with sweeping up the dust.

Since money was always scarce, the miner's wife had to make do with what they could afford. Curtains were made out of coarse muslin and sometimes dyed with coffee grounds. The rug was also apt to be made from muslin, braided by hand. And muslin was also used for sheets, pillowcases and towels. Underwear was often made out of flour and potato sacks. She was also expected to be a good knitter who could turn out socks, stockings, caps and scarves.

The interior of a miner's cabin, as depicted in *Harper's Weekly*. *Cheryl Blosser.*

Miners' wives likely had to carry water for drinking and washing for some distance from the pump house or well. On washday, the wives often helped one another by forming a bucket brigade to fill the copper kettles on the kitchen stoves. The clothes were boiled, scrubbed on a washboard and then hung outside to dry. However, they could not remain outside too long or they would be blackened with coal dust. Each day, when her husband returned from the mine, she would assist him as he bathed in a zinc tub in the kitchen.

To the extent possible, the wife would maintain a garden. As Eric McKeever has written, "At the peak of hard coal mining, patch towns were as ubiquitous as the breakers and mines. The term 'patch town' originated

with the custom of the wives of the miners having small garden patches to supplement the meager wages of their husbands."[59]

The children, of course, were required to help tend the garden and also assist with canning fruits and vegetables. The miner's wife would also bake bread, sometimes using a beehive oven. She was also expected to be able to treat many minor injuries and illnesses using folk remedies (e.g., nine drops of kerosene taken on a spoonful of sugar was the cure for the croup, or swelling around the vocal chords). But most of all, her job was to be there for her husband. This was never truer than during the Great Strike.

A wood engraving published in *Frank Leslie's Illustrated Newspaper* on October 25, 1884, showed Pinkertons escorting "Blackleg" or non-union workers through a large crowd of menacing women. Some are shouting, and others are holding clubs in a threatening manner. The scene had been sketched by Joseph Becker at Buchtel. The image of the miners' wives purportedly helped to garner sympathy for the strikers among the newspaper's readers. It helped them to understand that it wasn't just the lives of the miners that were at stake but those of their families.

One daughter of a mineworker, Velma J. Cochran, told this tale:

> *When Daddy walked in from work and set his lunch bucket down, we kids would quickly open it to eat the double butter sandwich and hunk of cheese. It seemed like a good treat, like he had kept it just for us kids, but when I got a little older, I learned that all coal miners left food from lunch in their buckets and also water in the bottom section every day. It was a thing of preparing for the worse, that is, a cave-in that would take days to dig out of.*[60]

Of course, children always assume that their fathers will come home from work. Wives, on the other hand—especially the wives of miners, fishermen, loggers and other men whose jobs involve a high degree of risk—are not so confident. During the late nineteenth and early twentieth centuries, coal miners in Ohio knew the dangers, and because they accepted them, their families had to as well. But they had few illusions about beating the odds. If they weren't buried alive, they would wind up with the living death of black lung.

During the 1890 United States Census, 219 women were identified as coal miners, although there was some question about whether they actually went down in the mines. Ten years later, the number had increased to 624. In 1918, it was alleged that there were women working in coal mines in some parts of West Virginia, despite a state law specifically prohibiting it.

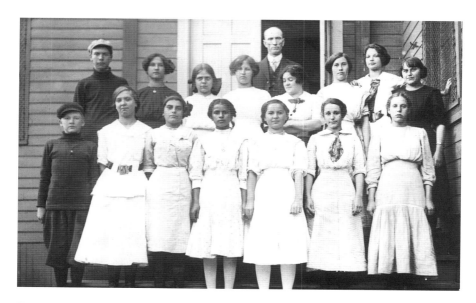

The girls outnumbered the boys in this class at Drakes School. *William E. Dunlap.*

Despite anecdotal accounts of female miners, it could well be that they were not generally accepted in the mines due to the prevalent belief that they would cause bad luck: "A woman is as welcome in a coal mine as a Republican would be in South Carolina or a bad case of itch to a man in a strait jacket."[61] As Douglas Crowell wrote in *History of the Coal-Mining Industry in Ohio*, "Some superstitious coal miners might point out the fact that prior to the explosion in the Willow Grove Number 10 mine in 1940, the mine was visited by several women, including First Lady Eleanor Roosevelt in April 1935."[62]

The use of young boys in the mines, however, was a practice that immigrant miners brought with them from their home countries.[63] Many biographies of coal miners mention that they first started working in the mines when they were children. The rise from a boy in the mines to mine operator was a legendary success story. William B. Wilson, secretary of labor under President Woodrow Wilson, had started working in a coal mine at the age of nine. Patrick A. Collins, an Irish immigrant, went to work in an Ohio mine at fourteen, graduated from Harvard law school and became mayor of Boston after serving as a Massachusetts state senator, a U.S. congressman and the U.S. consul general to London. John McBride started in the mines at age nine and was elected president of the United Miner Workers of America at thirty-eight. In fact, so many boys were working in the mines that a special provision was included in the mine laws of Ohio:

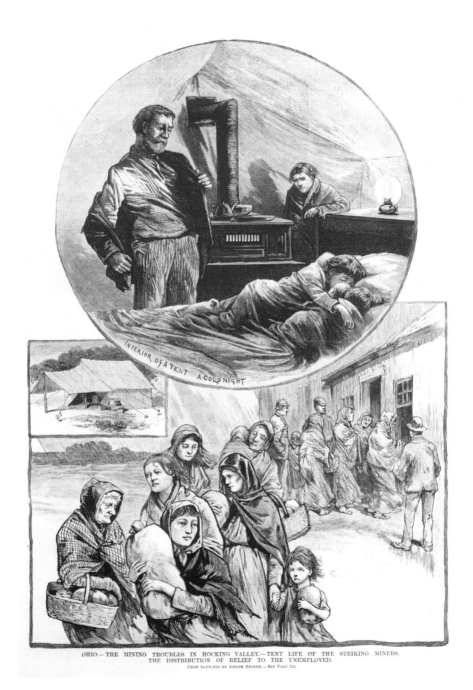

OHIO.—THE MINING TROUBLES IN HOCKING VALLEY.—TENT LIFE OF THE STRIKING MINERS. THE DISTRIBUTION OF RELIEF TO THE UNEMPLOYED.

FROM SKETCHES BY JOSEPH BECKER.—SEE PAGE 203.

Unemployed miners receiving relief, as drawn for *Frank Leslie's Illustrated Newspaper*. *Library of Congress.*

*[N]o boy under twelve years of age shall be allowed to work in any mine, nor any minor between the ages of twelve and sixteen years, unless he can read and write; and in all cases of minors applying for work it shall be the duty of the agent of such mine to see that the provisions of this section are not violated.*[64]

Crowell noted that a boy would often enter the mine as his father's helper or a trapper boy. He would then begin to move through the ranks from mule driver to laborer and, ultimately, miner. Many began in their early teens and some as early as eight or nine. Although he did not actually work in the mine, a breaker boy was charged with removing impurities from the coal. He would sit on a long bench, hunched over a conveyor belt, as pieces of coal flowed beneath his fingers. Most breaker boys were between the ages of eight and twelve. It was dangerous and labor-intensive work. In 1880 alone, the state of Pennsylvania had an estimated twenty thousand breaker boys.

When John Spargo visited Ohio coal mines in 1906, he reported:

*Work in the coal breakers is exceedingly hard and dangerous....From the cramped position* [the boys] *have to assume, most of them become more or less deformed and bent-backed like old men. When a boy has been working for some time and begins to get round-shouldered, his fellows say that, "He's got his boy to carry round wherever he goes."*[65]

One of the advantages of using boys was the height of the coal face. The thickness of the coal seam varied throughout the Hocking Valley from three feet to ten feet. The Great Vein, ranging in thickness from ten to fourteen feet, ran through Shawnee, New Straitsville, Congo and Baird's Furnace, while a thinner one of about four feet ran through Dicksonton, McCuneville and McLuney. The miner chipping the coal out of the seam would have to lie or sit down where it was thinnest but could stand where it was thickest. The most taxing position for the miner was where he had to crouch over because he could neither stand nor sit. This is where small boys came in handy. They could fit into tight places.

Young boys were so common in coal mines that they hardly deserved mention. However, when Lewis Hine, a former schoolteacher, went to work for the National Child Labor Committee, his stark photographs of young boys at work in coal mines provided the impetus for the passage of the Keating-Owens Child Labor Act in 1916.

But it wasn't just people who were subjected to the dangers of the mine. Into the twentieth century, mules, horses, oxen, goats and even dogs were used to haul coal. And in those days, mine safety was, to a large extent, dependent on a small animal. The miners would take a caged mouse—or, beginning in 1913, a canary—down in the mine to alert them to the presence of carbon monoxide. The bird did this by toppling off its perch, dead. In some cases, this provided them with enough advanced warning to make their escape. But not always.

# PRIDE AND PREJUDICE

*The very ink with which history is written is merely fluid prejudice.*
            *–Mark Twain,* Following the Equator *(1897)*

In 1871, the town of Ferrara, Perry County, was founded in wild expectation of the imminent arrival of what would become the Ohio Central Railroad. There was only one problem: it was coming from the north, and a steep range of hills blocked the way. So the railroad was delayed while a tunnel was, ever so slowly, constructed. Over the next several years, the town's three hundred residents moved on, unwilling to wait any longer. Finally, in 1879, eight years after the first spade of earth was turned, the Ohio Central (after several name changes) was once more bearing down on what was now a ghost town. Having snapped up most of the property from the original settlers, Joseph Rodgers, a native of West Virginia, laid out the town of Corning and sold all of the lots in seven months. His timing couldn't have been better. The demand for Sunday Creek coal was about to explode.

With coal mines sunk all around the town, Corning grew like pokeweed. Soon, the town had a stone quarry and the Lincoln paving brick plant. The original wave of miners had been Scotch-Irish, Welsh and English, but Germans, Italians, Hungarians and other eastern Europeans would gradually be added to the ethnic mix in response to labor unrest. For such a diverse group, they were generally tolerant of one another's differences, although outbreaks of violence were not unknown. Most mining towns were barely civilized, and Corning was no different. Tom Pirt, one-time marshal

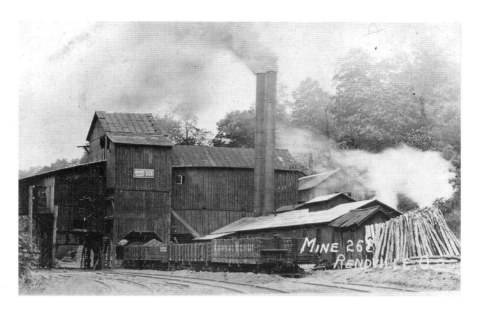

Mine 268, located one mile north of Rendville on the Toledo & Ohio Central Railroad. *Bruce Warner.*

of Corning (later a Columbus, Hocking Valley & Toledo railway detective), described it as a resort of criminals, thugs, adventurers, thieves and jealous husbands who occasionally shot their wives and one another.

Helping to keep things stirred up, the reliably racist *Hocking Sentinel* charged in 1886 that "the negro colony at Corning was established for the purpose of breaking down, driving out, or degrading the white workers in the mines."[66] Still, one exceptional resident of Corning was William Payne, an African American who grew up in Corning. He graduated from Denison University, served as assistant principal at the school in Rendville and became a professor at the West Virginia Colored Institute. Moving on to California, he helped found Allensworth, an all-black community. Its purpose was to transcend racial barriers.

Almost by accident, Corning evolved into a railroad hub—second only to Chicago for a time. Following closely after the Ohio Central were the Zanesville & Western in 1890 and the Kanawha & Michigan in 1893. A tunnel excavated between Corning and the new mining community of Congo enabled the Z&W to extend westward to Drakes, Buckingham, Hemlock, Ludington and Shawnee. In the long run, the railroads were more important to Corning's continued well-being than the coal mines. Then, on top of that, while drilling for water to supply the new railroad roundhouse

Reverend Adam Clayton Powell Sr. was "saved" at the Rendville Baptist Church. *Wesley Tharp.*

in 1889, they struck oil. From coal to railroads to oil, Corning had scored an economic trifecta that would keep it alive when many other towns died.

One mile north of Corning was a tiny settlement that had once been knows as Buxton's Mill after the local gristmill. In 1879, Colonel William Patrick Rend and Captain T.J. Smith (a merchant) of the Ewing Guards bought up all the available property and began selling off individual lots. The resulting town, made possible by the extension of the Ohio Central Railroad along Sunday Creek southeast of New Lexington, would be called Rendville.

An Irishman by birth, Rend was brought to the United States at the age of seven; grew up in Lowell, Massachusetts; and taught school before the outbreak of the Civil War. Enlisting in the army, he took part in a number of major battles with the Army of the Potomac and was the first man wounded at Yorktown. Moving west, Colonel Rend started as a freight-hauler in Chicago and evolved into the largest dealer of soft coal in the West. His holdings included full or half ownership in ten mines, half of which were in Pennsylvania and half in Ohio.

The paint had barely dried on Corning when Rend came to Ohio to supervise the construction of the new town and the mines. Neither was a company town, since a fair number of private houses and stores were also

being built. By 1882, when Rendville incorporated, the population already topped 1,200 and may have been as high as 2,500. Ten years later, a second railroad, the Shawnee & Muskingum, would also serve it.

Rend was not cut from the same bolt of cloth as most of his competitors. Not only did he favor arbitration in dealing with labor disputes, but he also bucked the practice of hiring only miners of European descent. His recruitment of African Americans became a bone of contention in nearby communities such as Corning, where they feared that the black miners would drive down wages. In 1880, he hired one hundred black miners from the New River region of West Virginia and relocated them to Ohio.

The introduction of a "sliding scale" meant that the miners would be paid at a rate that was tied to the current selling price of coal rather than a fixed rate per ton. Regarded with suspicion by the miners, they began to gradually reject it by walking off the job, all except the black miners. They worked primarily at Rend's Number 3 Mine, and their numbers had recently been increased by one hundred. The white miners at Shawnee, New Straitsville, Nelsonville and Corning came to associate the African American miners with depressing the wage rate.

Many of the new miners were staying in a hotel and boardinghouse at Rendville that had been recently built by the Ohio Central Coal Company. The hotel became a focus for demonstrations against the "immigrant" miners and the "sliding scale." Then, on August 29, 1880, someone burned it down. Instead of calling in troops, Colonel Wilson C. Lemert, superintendent of the Central Ohio Coal Company, decided it would be better to arm the new employees and train them in self-protection.

Three weeks later, word came that the white miners were on the march and intended to destroy property and chase the black miners out of the Hocking Valley. The managers were in continual communication with the governor and the adjutant general of the Ohio National Guard by telegraph, keeping them apprised of the situation. On Saturday, September 18, 1880, at six o'clock in the evening, Captain T.J. Smith of the Ewing Guards at New Lexington was ordered by Governor Charles Foster to assemble his men to travel to Corning. However, by the time they reached the train depot, the order had been countermanded. They remained on alert, and a special train was sent for them at ten o'clock the following morning.

When the militia arrived at Corning on Sunday, it found the streets swarming with a thousand or more agitated men. The troops were detailed to support the armed employees of the coal company. At Number 3, Captain Smith established a line ("deadline") that the demonstrators were forbidden

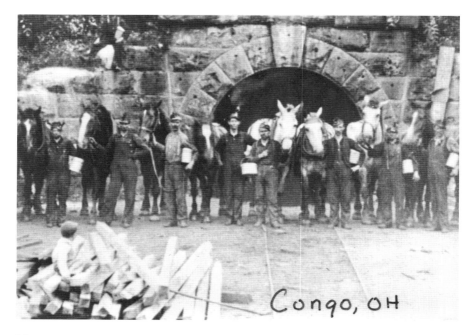

Miners posing before the mine entrance at Congo. *Wesley Tharp.*

to cross. Just after sunset, some three or four hundred of the angry miners approached the mine from the direction of Corning. Someone opened fired on the soldiers, and they returned fire. In the ensuing volley, three soldiers were seriously wounded, and perhaps fifteen to twenty more were injured. For many days afterward, it was rumored that one man had been killed and secretly buried, but no one was unaccounted for.

A planned march on Rendville to drive all of the black miners out of the valley was disrupted by the arrival of a battalion from Columbus, ordered in by Governor Charles Foster at the sheriff's request. To disguise their true intentions, the miners smuggled firearms into Rendville in hay wagons. There were several small squabbles, but the guardsmen quickly restored order in what would later be called the "Corning War."

The Fourteenth Ohio National Guards from Columbus arrived after the skirmish was over and remained on guard after the Ewing Guards were relieved at the end of a week. Troops were kept in place for some time after that. It wasn't long before the coal companies dumped the "sliding scale." However, the African Americans did not leave. By 1884, there were 300 black and 1,500 white residents of the community, mostly young males. With one bar for every 25 people, drunkenness and violence

were endemic. There were six murders and one lynching in the span of a decade.

Racial tensions did not dissipate. They erupted again in 1888 when a white man was killed in Corning, allegedly by an African American man from Rendville. Once again, mob action was feared. However, Dr. Isaiah Tuppins, the mayor of Rendville (and the first black mayor in Ohio), was able to persuade the law in Corning to protect the suspect. "If the law will not protect us," he warned the marshal of Corning, "we will protect ourselves."[67] The mob was dispersed, and the prisoner was sent up to jail in New Lexington.

Very much a boomtown, Rendville had about ten good years. Dependent entirely on the coal industry, it began a steady decline during the 1890s. In 1895, things were so bad that the community sought relief from the state, declaring that 225 families were without food. An editorial in the *New Lexington Tribune* branded the black miners of the town as a "horde of barbarian niggers" who "drove the white men out of their houses and compelled white women and children to settle in dugouts."[68]

In 1897, the *Hocking Sentinel* fanned the flames by charging that W.P. Rend supported importing as many as ten thousand "Chinese Coolies of Honolulu" to work in the Hocking Valley mines.[69] The paper reminded its readers that he had "established a town of negroes gathered from the slums of the South on the Sunday Creek. May he not, or others of McKinley worshippers of his kind, establish a Shanghai city in Ward township. He had his Congo and Rendville on the Sunday Creek. What's to hinder him, with Hawaii annexed, bringing the 'Citizen Chinese' as he has the 'Citizen Nigger' into the Monday Creek and Snow Fork valleys."[70] Twenty-five years earlier, the *Highland Weekly News* had reported that Peter Hayden had sent to California to obtain 150 Chinese workers for his coal mines.[71]

Rendville suffered a major blow on October 2, 1901, when a fire destroyed sixteen buildings, including a Baptist church and the town hall. Although they were all rebuilt, the village's decline would continue almost unabated. Nevertheless, in its brief life, the town produced several prominent citizens, including Richard L. Davis, a labor organizer, and Pastor Adam Clayton Powell Sr., founder of the Abyssinian Baptist Church in New York City. Powell described Rendville as "the most lawless and ungodly place I have ever seen. Every house on Main Street except the mayor's office and the post office was used as a gambling place."[72]

Davis, a founding delegate of the United Miner Workers of America, came to Ohio from Virginia in 1882 at the age of eighteen. He quickly joined the local Knights of Labor Assembly 1935, the "colored" branch of

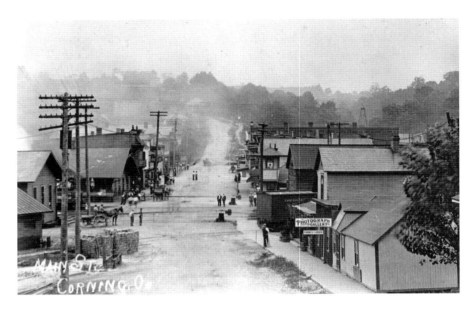

Main Street in Corning, the railroad center of the Hocking Valley. *Bruce Warner.*

the union. He moved into a position as an organizer for the United Mine Workers Union, traveling as far as Alabama in an effort to bring more African Americans into the fold. The intent was to undermine the efforts of the mine owners to use blacks and other ethnic groups as strikebreakers, driving a wedge between the miners. It was a dangerous job, especially in an era when blacks were frequently lynched, but Davis did not shy away from it.

One of Davis's challenges was persuading the African American miners to remain in the union despite continuing racial friction. When a black miner was promoted to foreman at a mine near Rendville and a group of white miners refused to work for him, Davis had to arbitrate. The black miners threatened to break away to form their own union, but Davis convinced them that it was better for them to place class solidarity above racial. Not all agreed, however, and Davis often found himself at odds with the more militant African American workers. In 1896, he nearly lost his job as a check-weighman because some of them branded him a traitor to his race.

Ultimately, Davis was "blacklisted" for his efforts. Unable to find work, he wrote a letter to the *United Mine Workers' Journal* in 1899, in which he described his plight:

> *I have spent sixteen years, and today I am worse off than ever, for I have no money, nor no work. I will not beg, and I am not inclined to steal, nor*

*will I unless compelled through dire necessity, which I hope the good God of the universe will spare me. I cannot think of my present circumstances and write more, for fear I might say too much. Wishing success to the miners of this country, I remain, as ever, a lover of labor's cause.*[73]

Davis, who was subsequently hired as the township constable, died just a year later of pneumonia, leaving a wife and two children.

Congo, two to three miles northeast of Corning, was a company town, planned and built by the Congo Mining Company, a subsidiary of Sunday Creek Coal Company, in 1891. At one time, Sunday Creek was one of the largest coal companies in the country, and it was responsible for the founding of dozens of small towns in Ohio. However, Congo was the pinnacle when it comes to a company. As one *Ohio State Journal* reporter wrote in 1898, "This community might well serve as an example of a model mining town, except for the fact that the company had complete custody of the property rights." He had been impressed by its 250 houses, public water supply, amusement hall and reasonable rent policy. He had expected to find "downtrodden serfs" but, instead, had been pleasantly surprised (although he still noted the miners were unaccountably "gloomy" while working). Even Davis, the African American leader of the United Mine Workers, overcame his initial reservations and pronounced the Congo mine the best place to live and work in the entire Hocking Valley.

The Congo mines, 301 and 302, employed one of the most racially and ethnically diverse workforces to be found anywhere. Irish, Hungarian and Slavic miners worked side by side with African American ones. Many explanations have been offered as to how the community got its name. For example, it has been suggested that it was nicknamed "the Congo" because of the many black residents. Another story is that it was named after "Congo" Mooney, an African American from Alabama who a decade earlier had come to Ohio and found work laying rail for the Columbus, Shawnee & Hocking Railroad. With his engaging personality, he became something of a hero to other African American railway workers, who began calling him "The Congo." One "suburb" was dubbed Alabama Hill.

Even though the miners, black and white, worked together, they did not live together. There was a strict line of demarcation between the homes of the blacks who lived on one hillside ("Nigger Hill") and the whites who lived on another ("White Hill"). During the 1920s, the Ku Klux Klan attempted to gain a foothold in the region, focusing their hatred on the Catholics, Germans and African Americans who were working in the mines.

Congo was largely the idea of Henry D. Turney, who had been secretary of the hated Syndicate during the Great Strike. Inspired by Chicago's George Pullman, who had sought to establish his own ideal community (named after himself), Turney set out to build a model community of his own. The Congo Mining Company started out by building forty houses, all identical except for a choice between one and two bedrooms. Even as other coal mining towns were proliferating, a railroad official quoted by the *New Lexington Herald* predicted that "Congo will be a larger town inside two years than Corning." The goal was to have 250 houses by then.

However, only one year later, in the spring of 1892, Columbus-based Turney Jones Coal Company (also owned by Turney) purchased the mine. Despite fears that this would derail plans for the town, Turney-Jones moved ahead by constructing more houses and updating the mine with the newest mining equipment available, courtesy of Jeffrey Manufacturing. Long-standing miner fears of being replaced came true the following year when many of them lost their jobs as the Jeffrey Electric Chain and Drill machine pick was introduced.

With the changes that were implemented, worker morale declined. Then, in the fall of 1895, the miners struck because their water supply had become contaminated. At least two people died, and another twenty were ill, presumably from typhoid fever. The water was obtained from a small creek and pumped through a hydrant system. Testing demonstrated the presence of drainage from farm privies, as well as excreta from cattle that had access to the creek. At the time, there were 148 company-owned houses in the village. No one who did not rent a home was permitted to work in the mine. All miners were paid with company scrip and had to shop at the company's general store. A small fence had been built around the town to discourage outside vendors from attempting to sell their products there.

Nevertheless, the *Athens County Gazette* reported on November 17, 1898, that Turney-Jones Coal Company had been placed in the hands of a receiver, including both the Congo mine and one at Shawnee. The company's liabilities were pegged at $1.2 million. The reporter speculated that the future of the Columbus, Sandusky & Hocking Railroad was also bleak, as it had been accepting notes in lieu of payment for freight and because there were few other mines using the line.

Life went on, and mining continued at Congo under the new ownership. In 1912, Congo made the news when a fire broke out in mine Number 302. At the time, there were four hundred men employed there, and one hundred were engaged in fighting the fire. Then, in 1931, well into the Great Depression, the Buckingham Coal Company took over the mining operations in Congo.

# DIVISION AND UNION

*The labor movement was not originated by man. The labor movement, my friends, was a command from God Almighty.*
*—Mary Harris "Mother" Jones (1912)*

Labor unions had existed, informally and on a small scale, since before the Revolutionary War, when fishermen in Maine went on strike in 1636. With the advent of the Industrial Revolution, however, labor in America began to change. There were now opportunities for millions of low- and no-skill workers coming from both rural America and abroad. This incentivized the high-skilled "masters," on one hand, to form guilds of sorts for the purpose of collective bargaining and the lower-skilled workers, on the other, to form groups to protect their health and rights.

The earliest workers' organizations in Ohio were fraternal or mutual-aid associations, primarily intended to provide them with sick and death benefits. Gradually, such benevolent societies were displaced by trade unions. The first trade union in Ohio dates back to 1828, when Cincinnati printers formed the Franklin Typographical Union. Four years later, Columbus printers did likewise. Then, in 1836, the Cincinnati Harness Makers' Union went on strike for higher wages and a ten-hour workday. Although President Martin Van Buren ordered all federal offices to observe a ten-hour day in 1840, it would be a dozen years before the Ohio legislature enacted a ten-hour law. Although it was deeply flawed and largely unenforceable, it provided a glimmer of hope.

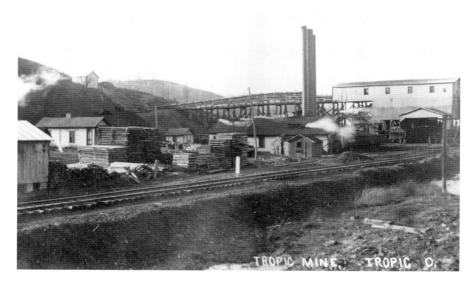

The Tropic Mine was located on Rose Farm south of Crooksville. *Wesley Tharp.*

The need to organize had been weighing heavily on the minds of Ohio's mineworkers for several years. Their counterparts in Illinois and Missouri had united in 1861 as the American Miners' Association (AMA) in the first attempt to form a national union. Two years later, they were joined by miners in the Tuscarawas Valley, who founded the Massillon Miners' Association. Although the union gained momentum during the Civil War, the AMA fell victim to a sluggish market and internal dissention in the years that followed and had folded its tent by 1869.

The Miners' and Laborers' Benevolent Association, founded two years before, went national in 1872, having gained a foothold in the bituminous coal fields of Ohio and surrounding states. It was the spirit of the AMA repackaged under a different name. However, it was squashed just three years later after a disastrous six-month strike. During the summer of 1873, an industrial congress representing all trades met in Cleveland, Ohio. Upon adjournment, the delegates representing the miners remained to discuss their mutual concerns and resolved to convene a national convention of miners in October at Youngstown. Their hope was to establish a national miners' organization—the Miners' National Association of the USA (MNA).

John Siney, the union's champion in Pennsylvania, was elected president, and Cleveland was chosen as its headquarters. Siney sought to unite all mineworkers in a single industrial union. Even as they were organizing, the

financial panic of 1873 was rocking the country, and the demand for coal fell 50 percent. Siney immediately reached out to every coal operator in Cleveland but was turned away by all but one: Marcus "Mark" Hanna.[74] The future senator from Ohio had only one question: would the MNA agree to the decision of an arbitrator if it went against them? Assured that they would, he replied, "Then, I am heartily with you."[75]

With the existing contract scheduled to expire on March 31, 1874, the Hocking Valley mine operators unilaterally decided to change the unit of coal measurement from cubic inches ("tape measure") to weight (ton). The newly formed MNA responded by ordering a strike. W.B. McClung of the Straitsville Coal and Iron Company had gone to Columbus the day before to arrange for a posse of police officers—each armed with Colt revolvers, navy pistols and Spencer rifles—to provide protection to the sixty non-union miners he planned to introduce into his mine. His force was met at Straitsville by a mob of some five hundred to six hundred miners with shouts of "blacklegs," "thieves" and "kill them." Wives of the miners flapped their aprons in the face of McClung's fourteen-year-old son.

Finding themselves outnumbered and surrounded, McClung and his men holed up in a storehouse. Three boys from McClung's group were captured, and one of them was severely beaten. The next day, some 250 miners marched around the building, carrying the American flag, beating a kettle drum and playing an accordion. Maybe it was the accordion that broke his resolve, but McClung abandoned the effort to keep the mine in operation. Blaming the strike on "mischief-making men from the Mahoning Valley," W.B. Brooks & Sons struck its own deal with the miners, raising the agreed-on price of sixty-two and a half to eighty cents to sixty-two and a half to eighty-seven and a half cents.[76] But none of the other coal companies followed his lead.

Six weeks into the strike, the situation was becoming increasingly volatile in Nelsonville, Logan and Straitsville. Appeals to Governor William Allen for assistance in controlling the rioters were denied. Allen said he was sympathetic but could not legally act until he received a request from Athens County sheriff Nehemiah Warren, but the sheriff's sympathies were with the mob. And so the lawlessness continued.

The miners had been on strike nearly eleven weeks when Miner Thomas Ames ("Miner" was his given name), a Chicago capitalist and part owner of the Lick Run Coal Company, came up with the idea of employing African American strikebreakers. He was supported in this decision by Longstreth, Brooks and McClung. On the evening of June 11, 1874, a special train left

*Puck* magazine called James Blaine the "False Friend of the Workingman." *Library of Congress.*

Columbus for Nelsonville with a secret cargo of four hundred black miners. Many were "old soldiers" from Virginia, Kentucky and Tennessee.

As the men disembarked from the train at three o'clock in the morning, they were furnished with Springfield rifles and Colt navy revolvers for the half-mile march to Longstreth's mine. They were described as a rugged group. Some had military service, and a few had just been involved in the Brooks-Baxter War in Arkansas. Three blacks and one white were fired on, and two died. This was the beginning of the "Black Diamond War." (See Appendix II: Come All You Jolly Miners.) When they reached the mine, some were placed on picket duty, while others were drilled with muskets. Since they had been unable to deter the black miners by force, the strikers next tried to induce them to join their side by offering them whiskey. Twenty-five to thirty accepted the offer.

On Thursday, June 11, Thomas Pirt was down at the mine, trying to talk the black miners into laying down their arms. He promised to do his best to protect them, even as some random shots were being fired. Pirt had entered the mines as a boy of seven in his native England. Born in Craulington, Northumberland, in 1841, he left for America in his early twenties, despite being bound to work for an English coal company for another year. Arrested aboard the ship *Louisa Ann* just before it set sail, he was subsequently tried and acquitted of breaking his contract. On his second attempt to leave England, his ship was wrecked and had to be towed back to Queensland,

Ireland. Finally, in 1862, he made his way to New York City and, from there, to Wilkes-Barre, Pennsylvania.

Two years later, having earned $4,800 from a coal mine he opened, Pirt returned to England. Putting together a group of miners, he went to Prussia to sink several more coal shafts. However, his intent all along was to become an American citizen. After returning to England for a time, he came back to the United States. He stopped off in Wilkes-Barre and Steubenville before arriving in about 1871 in Nelsonville, where he was elected district president of the local miners' union, serving for ten tough months.

When rumors reached Columbus that the striking miners would march on the mine, Governor Allen ordered Chillicothe's Sills Guards, Cincinnati's Lytle Greys and Nelsonville's Smith Guards to be on call. He also dispatched his personal secretary, I.H. Putnam, to monitor the situation in conjunction with Sheriff Warren. They arrived on Friday, June 12, and went to the mine, where they found two breastworks had been constructed and pickets were on duty to challenge anyone who came near.

At nine o'clock, Thomas Pirt and a procession of nine hundred angry miners came walking up. Putnam went out to meet them and talked them into not approaching any closer. Pirt agreed to do so as long as a delegation of miners could talk to the African American workers. They did so, accompanied by a band that drew the blacks near. Pirt told them they shouldn't take jobs from white miners, shouldn't work for less pay and that they would be enslaved. He also promised that the miners would pay their way home if they chose to leave. Several squads of African Americans quietly crossed over the picket line. More than one hundred would eventually quit. More black miners would leave as the white miners returned to work and fights broke out.

When the strike failed, the *Hocking Sentinel* asserted that the miners had been defeated by a "gang of Africans." The *National Labor Tribune*, the newsletter of the MNA, went even further: "This crowd, composed mostly of ignorant, dissolute villains…were hurried from their miserable, filthy dens, into the beautiful Hocking Valley of Ohio, where a few hundred honest, hardworking miners have for years past been struggling to build themselves and their children little homes."[77]

Pirt left the union toward the end of the year. It may have been that he was blacklisted because of his union involvement, but it is also possible that the other miners felt he sided too closely with the owners. On February 14, 1876, Pirt took a job as a guard at the Ohio Penitentiary in Columbus for fifteen months. Two years later, he was still residing in Columbus but

working as a stonemason. During the five or six years he lived in Columbus, he was not involved in coal mining. Then, in about 1881, he moved to Corning, where he became the town marshal and also superintendent of the teams and teamsters for the Ohio Central Coal Company. During the Great Strike, he proposed to the Syndicate that he travel around the state to collect statistics on the wages being paid miners. Although he had been working since he was a young boy, Pirt apparently had picked up some education along the way. He then was called before the Ohio General Assembly in March 1885 to testify as an expert on the matter.

At one point, Pirt admitted that he had been accused by his fellow miners of being a "blackleg" because he urged them to look at the wage issues from the operators' perspective. He said he had been threatened by a man who came to his house in the dead of night, told him the "Molly Maquires" (who were contemporary with the Black Diamond War) were onto him and they would kill him if he did anything that was contrary to the interest of the miners. Not long afterward, he was hired as a detective for the Columbus, Hocking Valley & Toledo Railroad, a position he held until at least 1893.

Toward the end of 1874, miners in the Tuscarawas Valley were notified that their wage per ton of coal was being reduced from ninety to seventy cents. The decision of the arbitrator to fix the price at seventy-one cents left the miners highly disgruntled. Many felt they might have accomplished more by a strike. At the same time, Crawford Coal Company in Stark County had locked out its miners over a dispute regarding the check-weighman. When the operators said they would pay the miners nine cents more than the arbitrator had awarded if they withdrew their complaint, the non-union miners readily agreed. Weakened by its failures and in-fighting, the Miners' National Association was gone within a year.

Rhodes and Company, operators of the Warmington Coal Mine in the Tuscarawas Valley, continued to turn a profit by slashing miners' wages from one dollar to sixty-five cents per ton. By the spring of 1876, the miners had pushed back on the steady wage decline by calling a strike. In response, the Cleveland-based mine owners (which included Mark Hanna) brought in strikebreakers. When the miners confronted the "scabs," violence flared. Some mine supervisors were beaten within an inch of their lives, and several mines were set on fire. Although he was reluctant to do so, Governor Rutherford B. Hayes had no choice but to send in the National Guard, especially after public sentiment shifted toward the miners when the violence spread to Massillon and Canton. Perhaps twenty or thirty miners were rounded up for disorderly conduct, although only a dozen were indicted for rioting.

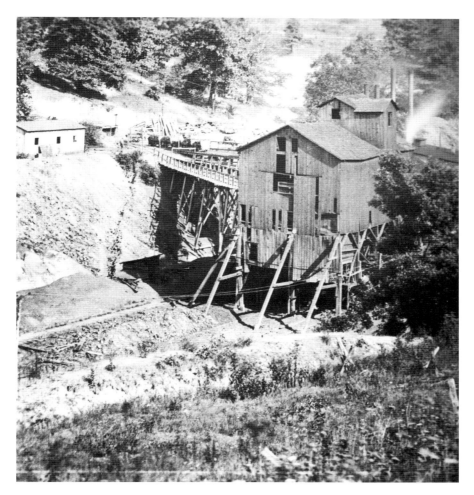

Daniel C. Jenkins was the owner of the Shawnee XX Mine. *Wesley Tharp.*

Owing to the delicate balance between Republicans and Democrats in Stark County, none of the local law firms wanted anything to do with the case. Finally, a young attorney named William McKinley agreed to defend the men—and for free. A Republican who was being viewed as a potential congressional candidate, McKinley knew that he was on shaky ground with the members of his own party. To protect him, the *Canton Repository* didn't even mention his name in reporting on the trial (and a biographer has claimed that his name was removed from the court record). However, word was bound to get out, especially since he was pitted against prosecutor William Lynch, a Democrat.

This has been acclaimed as McKinley's finest moment as an attorney. During a weeklong trial that commenced on Friday, June 23, 1876, he did not try to minimize his clients' violent acts but rather focused on the working conditions to which they had been subjected—the long hours, the risk of injury or death and the shrinking pay. In 1873 alone, more than 250 Ohio miners had been killed and more than 700 had been injured while on the job. But the mine owners had not suffered financially. In the end, one miner received a three-year sentence, while four others received thirty days and a collective fine of thirty dollars. However, McKinley had impressed both the miners, who would provide him with political support, and even Mark Hanna, who would become his political mentor. "Both men came to realize that political victory would lie in the strength of the alliance of labor and capital."[78]

Unfortunately for John Siney, his inability to control all miners led to his being charged with conspiracy and incitement to riot. Although he was acquitted, the MNA was mortally wounded and collapsed in the fall of 1876. Meanwhile, a secret organization, the Knights of Labor, began to gather support among the miners, starting in 1877–78. Organized by Uriah S. Stephens in 1869, it had ridden out the panic, which extended from 1873 to 1879, and now was ready to assert itself. In the Hocking Valley, Christopher Evans was a vocal advocate of the Knights.

An Englishman by birth, Evans came from Pennsylvania in 1875 on behalf of the union. He organized the first assembly, Number 125, at New Straitsville on September 23, 1875. Five months later, a second, Number 169, at Shawnee, was founded by Thomas Lawson, the master workman at New Straitsville. However, like many members of the Knights, he bristled under the dictatorial control of President David R. Jones, who lorded over them from his headquarters in Pittsburgh, Pennsylvania. Evans soon defected to form a trade union for miners, the Federal Association of Miners and Mine Laborers, and then worked on engineering a merger between the two groups.

Following the demise of the Miners' National Association, Ohio's miners were demoralized. Although they had local organizations, they felt they needed to belong to something larger if they were to make any inroads in changing their working conditions. In the Tuscarawas Valley, the miners had harbored a long-standing grievance concerning the practice of paying the miner for a lump of coal, only, and not the "nut" and "pea" coal that fell through the screen as it was being weighed. The companies sold these products, but the miner received nothing for them. The operators,

however, insisted that the payment for the small particles was included in the disproportionately high payment for the lump coal. So they went on strike late in 1879. With the arrival of the New Year and no resolution in sight, the miners called a convention to gather statewide support for their cause.

Among the delegates chosen was John McBride, who returned from Michigan, where he had gone in search of work. At a mass meeting in Massillon, he was chosen to head the delegation to a state convention in Mansfield. But all their efforts came to naught. After five months on strike, the miners gave up. This loss and the failure of the Hocking Valley and Jackson County miners to align with them on the screen issue so discouraged the Tuscarawas miners that the union came apart. McBride could not even obtain a job at the mine and went to work as a police officer in Massillon. Still, he did not give up.

At a meeting in Columbus in April 1882, a group of delegates founded the Ohio Miners' Amalgamated Association, with John McBride as its president. He would be reelected each year until 1889, when he became president of the Miners' National Progressive Union. Having gone into the mines of Stark County at the age of fifteen, McBride was a committed unionist. He was also secretary of Lodge Number 15 of the Miners' and Laborers' Benevolent Association. One year later, it became the Amalgamated Association of Miners of the United States at a convention in Pittsburgh. In 1884, McBride added to his laurels when he was elected a member of the state legislature from Stark County. Meanwhile, Christopher Evans, executive secretary of the American Federation of Miners and a resident of New Straitsville, would emerge as a leader during the impending troubles.

Unions weren't the only ones standing up for the interests of labor—or pretending to. While running for president in 1884, Republican senator James G. Blaine from Maine sought to portray himself as the workingman's friend. While stumping for votes in Ohio, he adamantly denied the rumors that he held an interest in any coal mines. However, just before the election, paperwork was discovered that revealed he owned shares in twenty-five thousand acres of Hocking Valley coal mines and nine iron furnaces through the Standard Coal & Iron Company of Columbus. Blaine subsequently lost to Grover Cleveland, although he still managed to win Ohio.

# STRIKE AND STRIFE

*A leader is a dealer in hope.*
*—Napoleon Bonaparte,* Maxims *(1804–15)*

**S**trikes were nothing new in the mining industry, but the first one to command the attention of the nation—and, indeed, much of the western world—was the Great Hocking Valley Coal Strike of 1884–85. For nearly nine months, all eyes were on Ohio as newspaper readers on both sides of the Atlantic eagerly followed the dispatches from the Hocking Valley coal fields. And it ended where it began—in New Straitsville—where, a visitor to the town once wrote, "A good deal of life is underground."[79]

Wage disputes were the most common reason for strikes. The Hocking Valley miners had rejected all proposed wage cuts and surrendered little ground by presenting a united front. However, as the mine operators became increasingly squeezed by the economic realities of competition, something had to give. Finally, in the spring of 1883, most of the operators save for W.P. Rend consolidated their holdings into either the Columbus & Hocking Valley Coal & Iron Company or the Ohio Coal Exchange. The purpose of these two conglomerates was straightforward—to weaken the miners' union—and they worked together in near lockstep to accomplish it.

The coal seam at New Straitsville and nearby Shawnee was ten feet high but dropped to six feet at Nelsonville and Haydenville. The operators felt that the miners who had the advantage of working a tall coal face should be paid ten cents a ton less than those who had to work a shorter one because

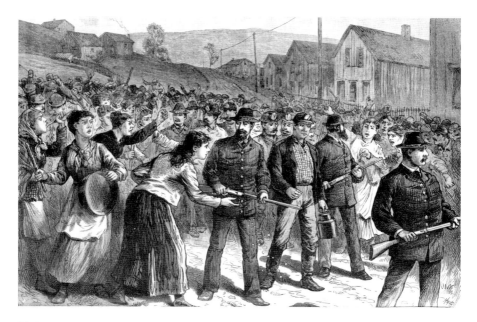

Pinkertons escort "blacklegs" through a crowd of hostile women, as depicted in *Frank Leslie's Illustrated Newspaper. Library of Congress.*

it required less effort. Naturally, the New Straitsville and Shawnee miners disagreed. The Nelsonville and Haydenville miners—and operators—did as well, although for different reasons.

Miners generally preferred working the thicker seam, so those mines were overcrowded with willing workers. Since most of the operators also owned company stores, they hired all the workers they could in order to give their stores more business. However, the more workers on the payroll, the less work there was for each of them. Consequently, the miners had difficulty earning enough money to support their families. Many a miner, quite literally (as Tennessee Ernie Ford sang), would "owe [his] soul to the company store." So, during their idle hours, they discussed their mutual grievances.

By 1884, the coal industry had plunged into a depression. The Syndicate and Exchange needed to lower the cost of producing a ton of coal in order to compete with other coal fields and provide their miners with steady work. The customary pay cut in March 1884 from eighty cents to seventy cents per ton, reflecting the transition from winter to summer pricing, had heightened an already tense situation. It was aggravated by yet another proposed cut to fifty cents per ton only a month later. The miners refused, believing this would create a domino effect in every competing field and result in yet

another round of wage reductions. Each mine had a mine committee, and the committees began calling meetings during work hours to address the issues that were bothering them. Strikes were called on the spur of the moment, sometimes as many as three a day. Their patience tested, the operators began to look for opportunities to retaliate against their workers.

The operators did not believe that the miners could endure a lengthy strike, so they unilaterally announced a ten-cent wage cut to take place on June 23, 1884. The miners rejected it and walked off the job. After two weeks, the operators declared they would cut the price per ton to fifty cents (instead of sixty) and that none of the strikers would be allowed to resuming working until they "signed a contract to work for such wages for one year, and agree not to join in any strike, nor belong to any miners' union for the purpose of raising wages; nor aid, abet or countenance any strike or combination or scheme for any purpose whatever, under the penalty of immediate discharge and forfeiture of all pay due at the time."[80]

There were other restrictions, as well, such as prohibiting miners from attending a meeting during working hours, all of which prompted the union leadership to double down and prepare for the worst. More than three thousand miners struck and forty-six mines were idled, despite the fact that most of the miners had neither money nor credit to sustain themselves and their families. An appeal went out for assistance, and aid quickly came pouring in from neighboring farmers and distant mine districts. Public sentiment was behind the miners, founded on the widespread belief that they were not being treated fairly.

With their mines shut down, the owners quickly brought in almost 300 unskilled Italian workers to work as strikebreakers and were able to add another 1,250 new workers—mostly Germans, Poles, Hungarians and Swedes, as well as some African Americans from Virginia—shortly thereafter. To guard the mines, the Syndicate hired the Pinkerton Detective Agency. When the Pinkertons (or "Pinkies") arrived in Ohio in July, they numbered one hundred and carried Winchester rifles. Hastily constructed barracks included portholes in the walls through which the Pinkies could fire their weapons if necessary. The detectives established deadlines and were ordered to shoot any striker who dared to cross them. But just ten days later, they were dismissed when the Syndicate decided that their services were not necessary because the strikers and the public were not molesting the non-union workers. Ironically, there was one report of a Pinkerton shooting and killing a drunken Italian strikebreaker.

OHIO.—THE MINING TROUBLES IN HOCKING VALLEY—STRIKING MINERS FIRING UPON "BLACKLEG" WORKMEN AT MINE 25, NEAR BUCHTEL.—FROM A SKETCH BY JOSEPH BECKER.—SEE PAGE 167.

Striking miners firing on non-union workmen. *Cheryl Blosser.*

The miners' reception of the "scab" laborers was unprecedented in its restraint. Local papers, such as the *Hocking Sentinel* and the *Athens Messenger*, as well as the union representatives, presented the foreign strikebreakers as pitiable fools who had been lied to by the evil mine operators. They were to be forgiven for their ignorance and not harmed since they were clearly poor and innocent victims of exploitation by the Syndicate. Their position became even safer when reports of the Italians leaving work to join the strikers began to circulate. The Hocking Valley miners felt their struggle was not just for wages but basic human rights. However, for every strikebreaker who left, another ten replaced him.

The *New York Times*, on the other hand, was firmly on the side of the operators. In its take on the story, the Hocking Valley miners had it easy. Due to the thickness of the coal veins, the workers had the luxury of working standing up or on ladders, as opposed to miners elsewhere who worked on their hands and knees because of the lower coal face. The benevolent mine operators were only reducing hours and wages so that they could clean out the mine and outfit it with new, state-of-the-art equipment that would make the miners' jobs easier, "let it cost what it might." The union was just stubborn and fought against the innovation, which would allow one miner to do the work of two. The *Times* strongly affirmed that "good will come from the breaking up of the tyranny of the Miners' Union."[81]

The strike remained remarkably peaceful until July 31, 1884, when the operators began to compel striking miners and their families to leave company-owned housing. In response to these evictions and lawsuits brought by the Syndicate to force even more out, miners began firing guns at trains carrying coal out of the region. They also attacked mine guards. While Judge Elias Boudinot ruled that the miners had not breached their rental agreements by striking, other judges were not so sympathetic and found for the Syndicate. This prompted a riot by four hundred miners in Buchtel. The strikebreakers were no longer safe, either. The original charm offensive (i.e., win them over by kindness) had degraded, as some of the union miners began carrying ostensibly unloaded guns to intimidate the scabs. On the night of August 30, 1884, those guns fired up to three hundred shots into strikebreaker camps at Longstreth, Snake Hollow and Straitsville. A mine custodian died, railway bridges were torched and coal cars were burned.

William O'Hara of Logan, a veteran and husband, was killed when he was shot in the head with buckshot by Frank Moody. A mine guard, he was heard to say, "For God's sake, men, have mercy," before he was killed.[82]

A striking miner gathers coal, as illustrated in *Harper's Weekly*. *Cheryl Blosser.*

Mine guards Jacob Lift of Logan and Adam Baurer from Germany were also injured but expected to recover. After Moody was imprisoned, he gave a full confession and also named two others who were allegedly involved. Three track layers—Barney Donnelly, Albert Riggs and William

Humphrey—were sleeping in a barn when armed strikers surrounded and attempted to kidnap them.

In response to unconfirmed reports that fifteen men had been killed in Buchtel, and of continued rioting at Sand Run and Longstreth, Governor George Hoadly arrived in Logan by special train at four o'clock in the morning on September 1 to take a firsthand look. He was met by Sheriff McCarthy. The day before, McCarthy had wired the governor: "All the means in my power are entirely exhausted to repress disorder and to protect life and property. The strikers are cutting all the telegraph wires. I am worn out. I have been going day and night for two months. Please send militia immediately and save further bloodshed. The jail is threatened."[83]

After meeting with local officials, including Judge Freisner, Colonel Seth Wiley and Sheriff J.T. McCarthy, as well as groups of aggrieved miners, Hoadly had tents shipped in for the strikers who were put out of their homes. He also ordered in four companies of Ohio National Guard to quell the uprising at Longstreth, Snake Hollow, Sand Run and Murray City.[84] Four men—John W. Free, J.F. McMahan, Orrin Macker and J.G. Huffman—sent the governor a telegram asking to be relieved of duty because "many of the members including the Captain of Company 'A' 17th regiment are coal miners who have relatives and friends in the Hocking Valley Mines."[85]

This only increased the miners' resolve. Efforts were made to provide relief to the neediest families through a commissary established at New Straitsville, with branches in Nelsonville, Shawnee, Buchtel and elsewhere. Those strikers who could afford to do so refused to accept anything for themselves. However, there still was not enough to go around, and the hardship and suffering were great: "Men without shoes waded through the frost and snow to the commissary; children subsisted on apples for days at a time; corn was grated on empty fruit cans, and baked into bread, and still the strikers had their colors nailed to the mast."[86] A committee under the presidency of Chris Evans would eventually distribute $26,740 in food and clothing and $70,335 in cash.

The mine operators were suffering as well. More than one thousand men had been shipped in to work in the mines, at great expense, and were protected by men who were paid better than they could expect to earn elsewhere. However, many of the scabs did not remain after they learned the circumstances of their employment. And the output of those who did remain did not offset the cost of producing it. John R. Buchtel, president of the Syndicate and regarded by the miners as an honorable man, was overwhelmed by the burden and conflicting pressures of his job and succumbed to paralysis.

With the presence of the state militia, the violence shifted from people to property. Now-vacant company homes were burned, and railroad bridges were destroyed on the Monday Creek and Sand Run lines. By that time, however, the strikers were getting tired. Many had to return to work or leave to find other work. Although public opinion remained on the side of the workers, the operators, with their power, money and unlimited supply of labor, continued to hold the upper hand.

Some four months into the strike, a handful of strikers decided that they had had enough. On or about October 11, 1884, they filled coal cars with wooden timbers soaked in oil, set them ablaze and rolled them into six mines in the vicinity of New Straitsville. It wasn't the first time striking miners had set a fire in a mine, but it was the most devastating. Most were extinguished within a few days or a week or two. But not this one.

Although there were more than four thousand people, miners and their families, living in New Straitsville, the fire went undetected for several days. By the time it was detected, it had been smoldering and spreading underground, following the fourteen-foot-wide coal seam. Although they made a concerted effort to extinguish it, the fire continued to burn and burn and burn. Eventually, the operator had no choice but to close the mine.

The strike ground on through Christmas and into the New Year. The suffering and distress of the miners and their families was heartbreaking. A newspaper correspondent visited Nelsonville in early December and described the scene: "[B]arefooted, ragged children were raking over the slag-heap for refuse coal. The women seem even more determined than the men to resist the operators. One woman, with scarcely enough clothing to cover her, said: 'I will go out and lie down on the bank of the creek and die with my baby in my arms before I will allow my husband to work for fifty cents a ton!'"[87] Meanwhile, the mines have been fortified so that four guards could repel an attack by one hundred strikers.

Feeling a need to do something, the Ohio General Assembly passed a joint resolution in January 1885 calling for an investigation into the causes and ramifications of the strike. It heard testimony from miners and operators alike, some of whom spoke in support of the other. Most miners who spoke objected to the "truck system" of company stores, complaining that they charged higher prices than neighboring stores and that subtle coercion was employed by the operators to compel them to give the stores their business.

"To the person not a native of the coal regions," wrote Eric McKeever, publisher of *Anthracite History Journal*, "it is difficult to comprehend how

The New Straitsville mine fire is the granddaddy of them all. *Cheryl Blosser.*

completely coal mining dominated every aspect of the life and physical appearance of the communities in the coal counties."[88] Under the truck system, they would receive their pay in company "scrip"—a voucher redeemable only at the company store. After they had purchased food and other provisions, they would receive the remainder—if any—in cash. However, many of them were already carrying debt and would receive nothing.

Of course, the owners who operated stores insisted they did so for the convenience of their employees and sold their wares as cheaply as their competitors. The legislature, in fact, enacted a bill prohibiting the coal companies from operating stores, but they got around it by taking on partners who did not hold an interest in the mines. In the same session, a law was passed calling for a state board to arbitrate wage disputes.

As far as identifying the cause of the strike, the committee determined that it was the eternal struggle between employee and employer over wages. Neither party sought legislation that would govern it out of fear that its rights would be infringed on.

From his church in Columbus, Dr. Washington Gladden was the Billy Graham of his day. Even though many members of his congregation were mine owners and operators (Thaddeus Longstreth was a member of the church board), he had the courage to speak out on behalf of

the mineworkers. He wanted the operators to see that "a labor union, when wisely handled and dealt with in a just and friendly spirit, is not necessarily an evil thing."[89]

The Great Strike ended on March 18, 1885, eight months and twenty-four days after it had begun. At a conference between the two parties, the mine operators withdrew their iron-clad contract. In exchange, the miners accepted a rate of fifty cents per ton. But both sides had lost, and both learned a lesson. The Hocking Valley miners and their counterparts across the country realized the importance of forming one national union. And the operators recognized that they would have to respect the miners as equals in the negotiating process.

Although the Great Hocking Valley Coal Strike would have a long-lasting impact on the Hocking Valley, and Ohio, it would not be the last for miners in the Buckeye State. There would continue to be tension between mine owners and mineworkers in the Hocking Valley, occasionally resulting in strikes, until the mid-twentieth century. However, the concept for an annual wage scale was born in the Great Strike and soon rolled out across the nation.

CHAPTER 13

# REGROUP AND RETRENCH

*Mining has rarely been carried on except by pioneers or slavery.*
*—John L. Lewis, UMWA president (1925)*

**W**hen the Ohio General Assembly convened in Columbus on February 20, 1885, to look into the reasons for the Hocking Valley Coal Strike, the first witness on behalf of the strikers was forty-five-year-old William P. Rend, the maverick mine owner from Chicago. Aligned with neither the Syndicate nor the Exchange, Rend was as critical of his competitors as he was the unions. "There are abuses and wrongs perpetrated by both interests," he asserted, "pride, greed, avarice and oppression on the part of capital at times, and unreasonable and unjust exactions on the part of labor."[90] His miners had walked off the job after a representative of the Syndicate had forcibly entered his Straitsville mine, "called the men together, and incited them to leave their work and join in the strike."[91] However, within a few weeks, they all returned, so he was able to continue production. But this did not end his involvement in the strike.

Later in November, Rend learned that the Hocking Valley Railroad had hauled away the hopper cars that his company had been using. When he demanded their return so he could continue shipping coal, the railroad's response was that they would do so as long as he did not transport the coal beyond the area covered by Hocking Valley lines. In other words, he would not be permitted to send his coal to Chicago and other more distant markets. Rend was subsequently able to resolve the matter in court and emphasized

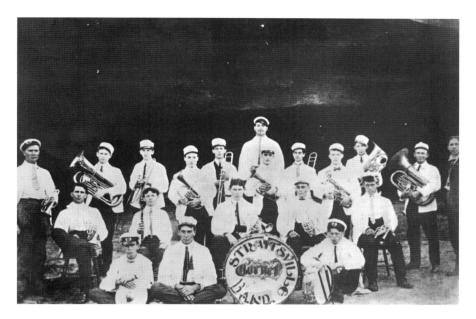

The Straitsville Coronet Band at Robinson's Cave in New Straitsville. *Wesley Tharp.*

that he had "no grievance against the railroad company."[92] Obviously, he tempered his outspokenness with the need to remain on good terms with those he was dependent on to operate his business.

By Rend's estimate, there were twice as many men working in the coal fields as were necessary to produce the amount of coal sold in the market. As a result, the miners in his employ and elsewhere had not worked more than two hundred days per year. It was a knotty problem that hinged on seasonal demand and the availability of empty hopper cars. Rend also testified that he found it "virtually impossible" to compete with owners who also ran company stores because they would sell their coal at cost and take their profit out of their store revenues. He attributed his competitors' treatment of the miners to the fact that

> *a great many men, who are now employing labor, are men who have never done any work; they don't understand the feelings, opinions and sentiments of the laboring classes. They don't understand the privations, trials and sufferings of the men, and often do not care anything for them. They seldom understand the positions their men occupy; they hold themselves aloof from them, and oftentimes regard themselves as a sort of superior beings.[93]*

Following the Great Strike, the Hocking Valley coal miners were a dispirited bunch. They had gambled everything and lost. The Knights of Labor saw their influence waning and numbers dissipating. Stepping into this leadership void was an English-born cigar maker, Samuel Gompers. Educated in trade unionism by his German-speaking co-workers, he had learned the German language to better communicate with them. Five years earlier, Gompers had been instrumental in founding the Federation of Organized Trades and Labor Unions. But his opportunity to seize the reins came at a convention in Columbus, Ohio, on December 8, 1886.

With representatives of 150,000 trade unionists in attendance, a new national labor organization was formed in a second-floor meeting room of the Druids Hall. Christened the American Federation of Labor (AFL), the body elected Gompers its first president. A coalition of thirteen national craft unions, the AFL was based on the principles of "pure and simple unionism" and "voluntarism." In other words, it would focus on increasing wages, reducing hours and the betterment of the lives of its members, while eschewing entanglements with the government.

As was often the case with prolonged strikes, the owners didn't have much cause to celebrate, either. Although the miners had accepted their original wage offer, it had cost the operators dearly in reduced production, vandalized mines and machinery, elevated labor costs and security expenses.

In hopes of heading off future strikes, the unions called for a conference in Indianapolis in September 1885. Delegates from Ohio and five other states had met in Indianapolis, Indiana, and formed a nationwide union, the National Federation of Miners and Miner Laborers (NFMML). Both Christopher Evans and John McBride from Ohio were key players, and Evans was elected executive secretary, the chief executive position. Evans, age forty-four and a resident of New Straitsville, was president of District Number 1 (there were a total of eight) of the Ohio Miners' Amalgamated Association.

The NFMML proposed a joint meeting in Chicago the next month where the employers and employees were to work together to resolve their differences—a first for the coal industry. Predictably, Rend was the only operator in attendance. Another convention was immediately scheduled for Pittsburgh in December. This time, a few other operators condescended to attend. The next meeting, on February 23, 1886, in Columbus, attracted more interest. Out of it came a sliding wage scale that varied according to geography, from fifty-six and a half cents per ton in some areas to ninety-five cents per ton in others. It was agreed to by both sides and would be in effect

from May 1886 to May 1887. However, it failed, as first the Illinois operators and then the Indiana operators withdrew.

Ultimately, the union began to splinter. It was during 1886 that the Knights of Labor started a miners' union named the National Trade Assembly Number 135. In December 1888, at a meeting in Columbus, there was an effort to consolidate the Trade Assembly into a new organization, the National Progressive Union of Miners and Mine Laborers, but enough members of the NTA refrained from participating that it continued as a separate body. The problem was these dissociated groups spent more energy battling one another than discussing issues confronting the workers in the mines.

The eyes of the nation had turned toward the Hocking Valley during the Great Strike. In its aftermath, the NFMML had established its headquarters in New Straitsville, where Christopher Evans made his home. It was joined by the National Trade Assembly Number 135. After the national conferences in 1888 and 1889 failed to bring them together, representatives of the rival unions, including Evans, began meeting in secret at Robinson's Cave in New Straitsville. The leaders were pushing for consolidation. Although there would be 221,000 mineworkers in the county by 1890, no more than 45,000 belonged to one of the unions.

Following the death of his wife, Evans moved to Nelsonville with his children and would remain there for the rest of his life. After serving as executive secretary of the AFL under Gompers, he would go on to organize miners in West Virginia and Colorado. While traveling to Pueblo, Colorado, in March 1904, he was attacked by three masked men while on board a Chicago & Southern passenger train. They used the butts of their revolvers to beat him on the head and face. He sustained fifteen to twenty deep wounds. Upon his retirement four years later, he penned a two-volume *History of the United Mine Workers*.

Finally, on January 20, 1890, everything came together. While holding separate conventions at Columbus, the National Progressive Union and the rival National Trade Assembly Number 135 put their differences aside and merged as the United Mine Workers of America (UMWA). The new union represented seventeen thousand miners spread over twenty-one districts. One of its strengths was its recognition that it would have to put aside racial and ethnic divisions and represent all miners. R.F. Warren, an African American from Ohio, was elected to its executive board, although he would soon leave. Richard L. Davis, an African American from Rendville, was also in attendance and would go on to be a member of the national executive committee in 1895.

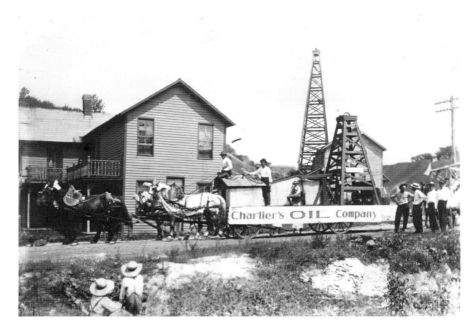

A parade float for the Charlier's Oil Company of New Straitsville. *Wesley Tharp.*

According to the UMWA constitution, it was going to focus on wages, fair weight, mine safety, an eight-hour workday, freedom from company stores, prohibiting child (under age fourteen) labor and instituting arbitration. John B. Rae, who cofounded the union with John McBride, was the first president. But after losing two national coal miners' strikes in 1890 and 1891, he refused to run for reelection. McBride then replaced him in 1892. He would preside over the union during the Panic of 1893, the worst financial crisis in the nation's history. More than four thousand banks failed, taking down some fifty railroads and more than thirty steel companies. The bottom fell out of the coal market. In the era before social welfare, the government at both the federal and state levels had no systems for alleviating the effect on the workers and took little action to do so. It was four years of unrelieved misery.

The spring of 1894 was particularly challenging for McBride and other union leaders. The coal mining industry was in dire straits when the UMWA called for a general strike on April 21, 1894, to return wages to what they had been a year earlier. Although 180,000 miners walked off the job in Ohio and four other states, they had nothing to show for it eight weeks later except for sporadic incidents of violence. On the heels of a failed strike by the UMWA in Illinois, Eugene V. Debs, head of the American Railway Union (ARU),

called a nationwide strike against the Pullman Company on May 11, 1894. While it was centered in Chicago, where the company was headquartered, it affected 250,000 workers in twenty-seven states, primarily west of Detroit. Essentially, any railroad line that used a Pullman car was targeted. Before it was over, 30 people had died and $80 million in property had been damaged. Debs would go to prison, and the ARU would be dissolved.

There were also echoes in Ohio. The ARU struck the Columbus, Hocking Valley & Toledo Railroad because the company had cut wages by 10 percent. In the spring of 1894, the striking miners were upset by the shipment of "scab" coal from Virginia and West Virginia through Ohio to markets in Chicago and the West. These shipments were carried by the Toledo & Ohio Central Railroad, which passed through the Hocking Valley. During May, the strikers disrupted the flow of coal by setting fire to the T&OC trestle at Truro, just west of Athens, according to the June 5, 1894 *Cincinnati Enquirer.*

At the request of the Athens County sheriff M.M. Riley, Ohio governor William McKinley dispatched troops to restore order and protect railroad property. However, he soon learned that local officials had grossly overstated the seriousness of the situation. The soldiers returned home. Realizing that he had been manipulated, the miners did not blame McKinley, who they knew was sympathetic to their cause, for his actions. But they didn't help him either. Quickly, things got worse. McKinley resisted sending the troops back to the valley until June 2, when the miners in the north seized coal trains entering the state from West Virginia. This time, McKinley responded by dispatching a total of 3,372 men, armed with Gatling guns and artillery, into the six-county area. He was counting on an overwhelming display of force keeping the lid on things, and it did.

Then, on the sixth, McKinley was notified that a mob of five hundred miners had blocked traffic on the Baltimore & Ohio Railroad in Guernsey County. He dispatched troops to disperse them, as well as troops to similar incidents in Belmont County the following day. By June 9, McKinley had assembled three companies of the Third Regiment to assemble in Columbus as a ready reserve. Soon, the governor was sending troops to Stark, Tuscarawas and Carroll Counties to deal with other incidents. Eventually, support for the strike collapsed, and a compromise was approved. Miraculously, no deaths or serious injuries were sustained by the strikers, although the National Guard lost one man to a cerebral hemorrhage and another to a skull fracture sustained while diving into the Tuscarawas River.

According to his biographer, McKinley "watched every movement of the troops for a period of sixteen days, remaining in his office nightly until long

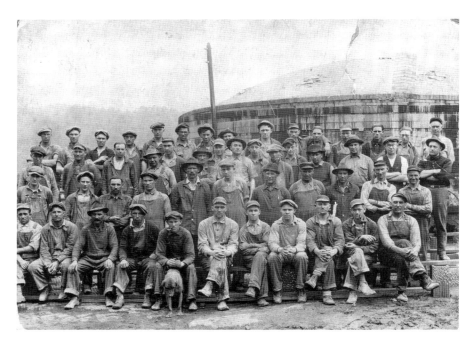

Peter Hayden switched from coal mining to ceramics in Haydenville. *Nyla Vollmer.*

after midnight and frequently telegraphing instructions as late as 3 a.m."[94] As a result, some miners were angry with him for deploying the troops but also at UMWA president John McBride for having discouraged them from stopping the trains by force. "Bridge burners, train wreckers and highwaymen are usually shot on sight," the *Cleveland Plain Dealer* editorialized, siding with those who decried the cost of mobilizing so many troops. The *Chicago Herald* deplored the fact that he had appeased "desperados and outlaws." It did not appreciate that he sent in troops only out of concern for the safety of all those concerned. He felt he had been backed into a corner.[95]

Mark Wild, an employee of the Toledo railroad and president of the union's grievance committee, represented the ARU in negotiations with John McBride of the UMWA, who was serving as an arbitrator. In July 1894, McBride gave Wild $600 to step aside and allow the strike to be settled. He did. The strike was quickly called off when the wages were restored, and the engineers and firemen received a large increase as well. It was agreed that all would be rehired except for Wild, who led the strike, and Sherman Linn, who presided over a few public meetings of the strikers. Later, Wild would claim that the money was a bribe; McBride countered that it was

meant to compensate Wild for the loss of his job. Nearly everyone sided with McBride, including William D. Mahon of Detroit, president of the Amalgamated Association of Street Car Employees. In June 1890, Mahon was a resident of Columbus and led a strike of local streetcar workers. Although he succeeded in getting them a higher wage, he failed with a similar attempt two years later. As a consequence, he left Columbus but went on to found the Amalgamated Association of Street, Electric Railway and Motor Coach Employees of America.

# LEAD AND FOLLOW

*Who gets the bird, the hunter or the dog?*
—*John L. Lewis,* Life *(1954)*

On December 17, 1894, John McBride was elected president of the American Federation of Labor (AFL), displacing Samuel Gompers. In response, the Boston *Labor Leader* trumpeted, "The king is dead! Long live the king!" Four years earlier, Gompers had revived the push for an eight-hour workday, picking up where the Knights of Labor had left off. The first Gompers-sanctioned strike was by the Brotherhood of Carpenters. As a test of its might, the union encouraged all AFL members to engage in demonstrations on May 1, 1890, to show their support for the striking carpenters. It worked. A record number of strikes occurred on May Day, and the carpenters, some forty-six thousand strong, won the right to an eight-hour workday. Emboldened by the result, AFL members staged 7,500 strikes in the first four years after its founding.

One of them, the Bituminous Coal Miners' Strike of 1894, involved 180,000 mineworkers, including those from Ohio and four other states. Once again, the issue was wages. McLainesville in northeastern Ohio was the site of a confrontation between the National Guard and strikers armed with rocks and clubs. Eight weeks later, however, the union lost, closed down their newsletter and stopped paying dues to the AFL.

Gompers, the "pure" unionist, did not want the AFL to become involved in politics. However, McBride felt that it had to become a political

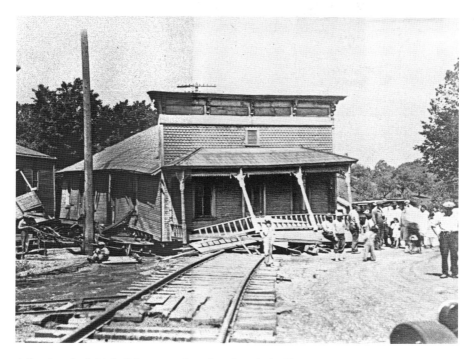

A flood washed this building onto the railroad tracks in Hemlock. *Wesley Tharp.*

force to ensure lasting changes in working conditions. As leader of a populist movement within the union, McBride unseated Gompers for the presidency—the only person to ever do so. Upon taking office, he resigned from the presidency of the United Mine Workers of America (UMWA).

By January 1895, one month after McBride's election, many Hocking Valley miners were destitute, and union representatives reached out to Governor William McKinley for assistance. McKinley immediately requested that local officials convene an advisory meeting and then report back to him with their conclusions. A few minutes before midnight on January 9, he received a telegram from them. "Immediate relief needed," it read.[96] One year earlier, the Ohio General Assembly had rejected a call for the state to provide relief for unemployed workers, arguing that it did not have sufficient funds and that such a program could not be justified as necessary. Consequently, the governor did not feel that anything would be gained by asking the legislature for assistance.

Despite the lateness of the hour, McKinley sent messengers to dealers in groceries, vegetables, flour and other staples, as well as a transfer company and officials of the Hocking Valley Railroad, asking that they meet with him

at once. He arranged to purchase a railroad carload of provisions, and by nine o'clock that morning, they had arrived in Nelsonville and were being distributed to the hungry miners and their families. Amazingly, McKinley was prepared to foot the entire bill (nearly $1,000) himself, but when his friends learned of it, they took up a collection to help.[97] Of course, this was only a temporary fix. During the ensuing weeks, there were other pleas for help. The governor put together a general relief committee and called on the boards of trades in Cincinnati, Columbus, Cleveland and Toledo to assist him in his effort.

On February 17, the chairman of the general relief committee issued his final report, which showed that 2,723 miners had been out of work. This translated into roughly 10,000 affected people, counting the miners, their wives and children, who had been fed at a cost of $32,796.95—all paid for through Governor McKinley's statewide appeal for charity. Despite his obvious compassion, he was "later caricaturized by cartoonists as a puppet of remote and harsh capitalists."[98] Such is politics.

During his single, controversial term as AFL president, McBride's popularity quickly dwindled as he became involved in union infighting. Although he described himself as a "limited socialist," he was branded as both too radical and too conservative. After he was defeated by Gompers in his reelection bid, McBride was at loose ends. He eventually landed in Globe, Arizona, where he was investigating a strike by copper miners as part of a commission appointed by President Woodrow Wilson. On October 9, 1917, McBride was standing on a downtown street corner when he was knocked through a plate glass window by a runaway horse. An artery in his leg was severed by the broken glass, and he quickly bled to death. He was sixty-three-years-old.

Other national leaders emerged from the Hocking Valley coal fields. The Lewis brothers—William T. and Thomas L.—are studies in contrast. Both were unionists, but Thomas would come to switch sides in order to advance his own career. The sons of Thomas and Mary Lewis, who had emigrated from South Wales to Pennsylvania in 1866, they moved to Shawnee, Perry County, thirteen years later. With ten or eleven children to feed (there were fourteen altogether), it was not surprising that the boys went to work in the mines when they were quite young.

William, the eldest, having been born in 1861, "entered the coal breaker at six and went down in the mines at age nine."[99] Although he was the sole support for nine of his siblings at age twenty-three (his father died in 1883), he studied nights and even managed to attend one term at the National Normal School in Lebanon, Ohio, while the Great Strike was in progress.

It goes without saying that he was an uncommonly bright and motivated individual. He quickly became a leader among his fellow miners because of his ability to advocate on their behalf. However, he did so from the belief that "capital and labor should work in harmony and on terms of equality—that neither should oppress the other—that both are essential in the full and complete development of the country."[100]

Recognizing his abilities, the Shawnee Knights of Labor elected him master workman of Local Assembly 169. Because it was one of the strongest chapters in Ohio, William was well positioned to replace William H. Bailey, also from Shawnee, when he declined to run for a second term as master workman at the National Trade Assembly (NTA) Number 135 convention in June 1877. As head of the NTA, William was instrumental in the formation of the National Progressive Union, becoming the organization's national secretary. After being admitted to the bar, William was appointed labor commissioner of Ohio by Governor McKinley in 1892. Dispatched to Europe to study how they dealt with labor issues, he helped craft the "Ohio Idea," which resulted in the formation of the first government employment offices, providing unemployed workers with jobs. William went on to become a successful attorney in Columbus. He died while on a visit to Cleveland.

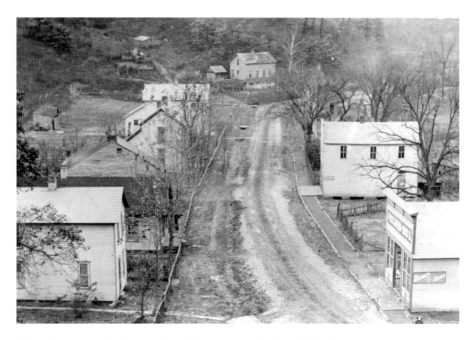

The unincorporated village of Luddington, west of Hemlock. *Wesley Tharp.*

Thomas L. Lewis, on the other hand, was born in Locust Gap, Pennsylvania, in 1865. Like his older brother, Thomas worked at the mines during the day before the age of seven and studied at night. And like his brother, he was known for his skill as a debater. Thomas also spent a term at the Normal College in Lebanon and then started attending night school classes. In 1889, he moved to Bridgeport, where he became involved in local government. From 1896 to 1897, he was president of the Ohio Federation of Labor. Thomas continued to work in the mines until he was elected secretary of the Ohio miners' union in 1897. Then, in 1908, he was overwhelmingly elected president of the United Mine Workers of America, an office he would hold until 1911.

In January 1897, the annual United Mine Workers convention was held in Columbus. The price of coal had dropped, and wages had plummeted yet again. Chief Inspector of Ohio Mines R.M. Haseltine reported that in 1895, the average miner earned $18.48 per month.

In Columbus, the union agreed on the appropriate wage that should be paid to each miner in each region represented, including Ohio, Pennsylvania, Indiana, West Virginia and Illinois, which represented 70 percent of workers and bituminous coal production. The National Executive Board and district presidents of the UMWA, including President M.D. Ratchford, met in Columbus a second time in June to declare the strike for Independence Day. According to author J.E. George:

> In the great Hocking Valley district in Ohio, which produces over one third of the coal produced in the State, during a period of eight months, from October 1, 1896, to June 1, 1897, the total average gross earnings in one of the largest mines were $60 per man, or $7.50 per man per month. From these earnings must be deducted the cost of mine supplies, such as tool sharpening and power; and only the remainder is left to the miner for house rent, coal, and food, not to mention any comforts.[101]

Then, in August, James Goodwin, secretary of the New Straitsville Relief & Distributing Committee, wrote to Chief Inspector Haseltine requesting aid for 800 miners from the Number 3 Rock Run and Lost Run Mines said to be starving, in the form of "food supplies such as flour, meat, tea, coffee, sugar, beans and soap." In return, the miners offered to guard the mines for free. By September, after more than 150,000 men joined the strike, the union voted in Columbus to accept a compromise. The strike ended shortly soon thereafter, bloodlessly and without violence.

# MINING IN THE HOCKING VALLEY

By 1899, the idea of unions was so well entrenched in American society that even the New York City Newsboys famously and successfully went on strike. However, that did not translate into smooth sailing across the board. Thomas Lewis's tenure as president of the UMWA was controversial, to say the least. He was accused of rigging elections and turning the union journal into a propaganda instrument for himself. "Tom Lewis served the union in a most trying time," wrote Damon Watkins in *Keeping the Home Fires Burning*. "Times were hard, personal jealousies existed among the lower officers, and many operators wanted to see the U.M.W.A. outlawed." But he kept it together. After he left the union, he went over to the other side, becoming an anti-labor consultant for coal operators in West Virginia and helping to found the National Coal Association in 1917. He died in Charleston, West Virginia, in 1939.

More than half of Ohio's coal miners were on strike during 1910. Mathematically, production should have been reduced 25 percent due to the loss of workdays. Instead, it increased 22 percent over 1909—the largest gain ever made in a single year. There were several reasons for this, but the principal one was that a cold winter had depleted the supply so that the year opened with demand high. Furthermore, the state continued to be the leader in the use of mining machinery, increasing efficiency while reducing manpower. However, it was not without cost. A total of 161 men were killed and 471 injured in Ohio coal mines during 1910. The value of the 34,209,668 tons of coal produced was $35,932,228.

As oil and natural gas were beginning to replace coal as fuel sources, the Hocking Valley miners continued to work sporadically, some in the shadow of the derricks. But it had become nearly impossible to earn a living. A "soft coal trust" had come into existence due to the purchase by various railroads—the Hocking Valley, Chesapeake & Ohio and Lake Shore—of the controlling interest in the Sunday Creek Coal Company and other mines. The effect had been to stifle competition by favoring their own holdings. A special U.S. District Court handed down a ruling in March 1914, dictating the method to be employed in breaking up this monopoly. Still, in 1915, Governor Frank B. Willis felt a need to include a green stamp that read "Buy Ohio Coal" on the back of every engraved envelope that left his office. "Dignity be hanged," he said, "I'm going to do all I can to help the miners in the Hocking district."[102]

Disputes with the railroads over shipping rates, a shortage of hopper cars and competition from mines in West Virginia continued to take a toll. During 1921–22, they miners did not average fifty days' work in a year. By 1925, the coal boom in the Hocking Valley, which had spanned more than half a century, was at an end. Newly opened mines in eastern Ohio and

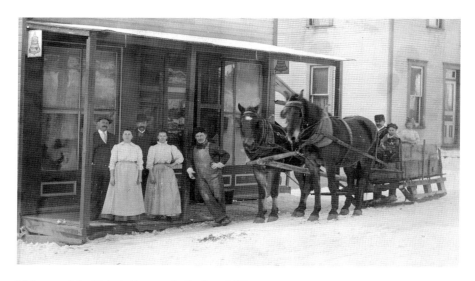

Visitors to John Reho's Grocery in Drakes. *William E. Dunlap.*

elsewhere were electrified and employed more efficient production methods. The contract negotiated by UMWA president John L. Lewis (no relation to the Lewis brothers) called for an eight-hour workday and an hourly wage that was beyond the means of the Hocking Valley mine operators. As a result, most of the mines were forced to close. As the country entered the Great Depression, a protracted strike that had long gripped the Little Cities of Black Diamonds was left unsettled. The glory days of the Hocking Valley coal fields were, for all intents and purposes, over.

During his forty-year tenure as UMWA president, Lewis tried to play the political game to its fullest in an effort to increase his own power. When he took control of the union, it purportedly had 500,000 members. However, his dictatorial manner drove many of them away and resulted in a division within the union in Illinois. Lewis also cut deals with employers, trading jobs for higher wages, which also reduced the ranks of the working men. Although he was also vice-president of the American Federation of Labor, he clashed with the craft unionists. Resigning from the AFL in 1935, he founded the competing Committee of Industrial Organization, which broke away from the AFL and rechristened itself the Congress of Industrial Organizations. (In 1955, they would reunite as the AFL-CIO.) Although Lewis continued to fight on behalf of the miners and, for the most part, won, the union's size and influence had greatly diminished by the time he resigned the presidency in 1960.

# SHADOWS AND GHOSTS

*The towns represent our primal aspirations, our national essence. They are America gone awry, hopes faded on weathered clapboard.*
—*Randy McNutt,* Ghosts *(1996)*

The Little Cities of Black Diamonds were once strung like charms on a bracelet across the coal fields of the Hocking Valley. Many of them were "boomtowns," owing their existence to the mines and the railroads that served them. But as the mines were abandoned, so were the towns, often after a generation or two. Some survive only as names on a map, and others have vanished from the map entirely. For many of them, even their histories are disappearing as those who once lived there pass away, leaving behind a handful of faded photographs and yellowed newspaper clippings. In New Straitsville or Shawnee or Haydenville, there remains a glimmer of what the communities were like during their heyday, but doddering buildings and piles of rubble are a constant reminder that they are also dying and may join the Kachelmachers, Chapel Hills and San Toys.

Whatever possessed the owners of the New England Coal Company to name the town "San Toy" (sometimes Santoy) may never be known for certain. It does seem more than coincidental that a musical comedy called *San Toy, or The Emperor's Own* had just opened in New York following a highly successful run in London. Did the company have a stake in the faux-Chinese operetta? Unlikely. Or could it be, as someone suggested, that one of the owners was born in St. Thois (San Toy), France? Far-fetched. Maybe it

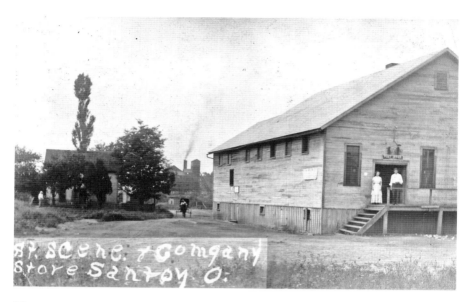

The company store at San Toy, "The Town that Ain't No More." *Bruce Warner.*

was to honor Sam Troy, a local fighter of some renown, and somehow got garbled in the process. Doubtful. Whatever the case, San Toy, Perry County, now stands as a monument to impermanence, a true ghost town with nary a brick left in place to testify to its existence.

Two Columbus businessmen formed the San Toy Coal Company. Levi Reinhart Doty, better known as "Captain" Doty, and Henry Denny Turney were already experienced coalmen. Doty was born in Springfield, Ohio, in 1847, attended Princeton University and became a hardware manufacturer in his hometown before turning his attention to the Hocking Valley coal fields. In 1871, he set up shop in Columbus and soon became president and principal stockholder of the Ohio Coal Exchange. Eighteen years later, he moved its headquarters to Chicago. He was still in charge when it was forced into receivership as a result of the Financial Panic of 1893. The cause was being undercapitalized for the amount of business it was conducting. In 1900, Doty was relieved of $5 million in various debts by the court in Chicago. It was noted that he only had $400,000 in assets, owing to the failure of several coal companies in which he was a stockholder. At that point, he returned to Columbus to focus on his Hocking Valley interests.

A native of Circleville, Turney was five years younger than Doty. After trying his hand at banking with William G. Deshler and steel-making at Columbus Rolling Mill, he secured a position with General Samuel Thomas,

soon ascending to the presidency of the Thomas Coal Company. During the Great Strike, he had served as secretary of the Syndicate. He later added the presidencies of the Columbus Gas & Fuel Company and the Darby Coal & Coke Company, as well as several other businesses.

As proprietors of the New England Coal Company, Doty, as president, and Turney purchased a large property in Perry County that they developed as San Toy. According to former San Toy resident W.G. "Shorty" Addington, the new owners intended to make of it a "modern mining system and a model community."[103] They quickly found they had a tiger by the tail. Soon, San Toy boasted a hospital, a post office, a drugstore, several saloons and a theater. Within five years, its population had grown to 2,500.

San Toy's reputation as a lawless town, while probably overblown, is based on some truth. Willis Stotts, for example, was shot to death in an argument over whiskey. His brother, Gus Stotts, was purportedly slain while attempting to prevent a holdup. In 1917, a roving peddler was killed for the goods he carried on his back, while Arthur Keeley, a saloon owner, was gunned down because he refused to serve alcohol to a young boy. The year 1924 was marked by a Wild West–style shootout in the streets when Henry Coleman was shot through the heart by John Marshall over a twenty-dollar debt. Marshall did not escape unharmed, sustaining a wound in the lung. Betty McElhiney, who was born in San Toy, recalled that "even the doctor carried his lantern at arm's length on night calls, so everyone could tell who he was. People were always ready to shoot."[104]

By 1911, the San Toy mines had fallen on hard times. Several years earlier, Turney and Doty had sold the mines and other coal property in Perry County to the Delaware & Western Coal Company. But the Baltimore & Ohio Railroad, having acquired a $300,000 mortgage on the property, foreclosed on it. As a result, the mines were sold to the San Toy Coal Company, whose president, J.S. Jones, was also president of the Jones & Adams Coal Company of Chicago. Both companies opened offices in Columbus for the purpose of operating the mines and marketing their coal. Then, in 1915, it was purchased by the Sunday Creek Coal Company.

San Toy owed its demise to a combination of factors. In 1924, a group of miners demonstrated against working conditions by setting fire to a cart of railroad ties and pushing it into mine Number 1. The resulting conflagration consumed several buildings, including the hospital (the only one in Perry County). When the company decided not to reopen the mine, some of the miners found themselves out of work. Three years later, the company shut down operations in mine Number 2 following a major strike. The company's

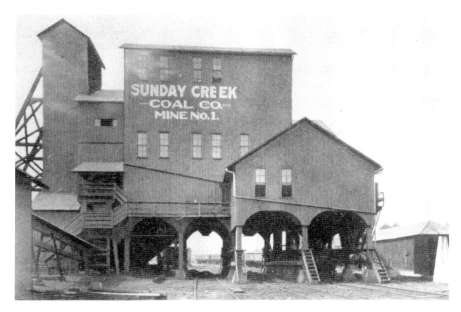

Fig. 39—Lower Side of No. 1 Tipple.

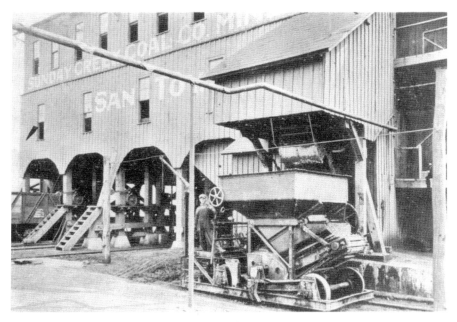

Fig. 40—Stacking Car for Refuse Disposal.

San Toy was featured in the October 1918 issue of *Electrical Mining. Authors' collection.*

position was that it could not continue without investing in expensive new equipment. The miners, however, believed that it was simply an effort to crush the local union. Both were probably true.

On April Fools' Day 1927, the mine at San Toy did not open, but it was no joke. The population of the town had dropped to 700 from 1,200 after a mine tipple was burned some time before.[105] With the mine closed, the town lost its source of water and power. The Sunday Creek Coal Company notified the out-of-work miners and their families that they could continue to live in company housing as long as they paid rent. Mayor C.A. McIntyre said that he did not expect a mass exodus from San Toy because "[t]he miners have weathered similar situations and are fully prepared for this emergency."[106] In 1930, the remaining residents were given the opportunity to buy their houses for fifty or seventy-five dollars apiece. One year later, they voted seventeen to two in favor of abandoning the town, even as their musical namesake was being revived in London.

As a young man, William Job learned coal mining methods in his native England, where he had been born in 1843, before immigrating to the United States. While in his early twenties, he briefly went to work in the eastern coal fields before settling in Ohio. In time, he established several mines and built the town of Jobs (pronounced with a long *o*) or Jobs Hollow in Hocking County. Just a mile down the road from New Pittsburgh, it included several mines, a row of houses and a post office. To look at, it had little to recommend it save the people who lived there. By 1888, his operation was second only to Nelsonville as a coal depot on the Hocking Valley Railroad.

Two years later, Job patented a coal mining machine that was designed to drill a hole and cut a seam laterally so that blocks of coal could be readily removed. Then, in April 1892, the miners at New Pittsburgh set a world record for loading 3,333 tons of coal in 168 railroad cars. It became a matter of community pride for the Jobs miners to surpass their rival, and they did so a month later when they loaded 4,888 tons in 243 cars. In order to set these marks, the miners in both towns had worked eleven-hour days (although the Jobs miners had already bested it in eight hours). Despite the mines' performance, the miners profited little by it. Home ownership in Jobs and New Pittsburgh, which was of comparable size, ranked at the bottom among Hocking Valley coal towns.

For many years, William Job lived at the Southern Hotel in Columbus and later resided in Chicago. He also opened the Hisylvania Coal Mine in Trimble, which ran from 1901 to 1925, and formed the Ohio Coal Washing & By-Products Company in 1915. However, the Jobs Post Office ceased

operation in 1924 after thirty-four years. The Sunday Creek Coal Company was the last to operate the mines. Job died in Roxbury, Massachusetts, in 1931, at the age of eighty-eight. He had retired ten years earlier and was living with his unmarried daughter. Like San Toy, nothing remains of this once thriving coal town.

Most of the Hocking Valley coal barons enjoyed their greatest success early on in the industry's history. The exception was Nils Louis Christian Kachelmacher. Born to wealthy parents in Tonsberg, Norway, on August 8, 1860, Kachelmacher, came to the United States at the age of twenty-one. It was three years before the Great Strike, which would have negative consequences for both the coal operators and the workers. The Columbus & Hocking Coal & Iron Company, for one, would not reopen most of its iron furnaces. However, by the turn of the century, it had once again become a major player in Ohio's coal industry. In what was described as a "battle royal" for control of the Columbus & Hocking Coal & Iron Company, the "Norwegian count," as Kachelmacher was known, won out over New Yorker William H. Ziegler, the company's president.

One of his first acts was to reopen the Bessie Furnace, which helped to prolong the life of the iron industry in the Hocking Valley by another fifteen years. He also developed the Kachelmacher Oil fields and expanded iron, natural gas and coal holdings. However, his most important contribution was the construction of the $1 million Greendale Brick Company, manufacturer of "rug-faced" brick, which was once the largest brick-making plant in the world. To accomplish this, he had a novel idea. In order to continue construction on his plant during the winter, he erected a large tent over the construction site. The goal was to prevent the mortar and cement from freezing while the kilns were being built. A number of coal-burning stoves were placed under the tent to warm the air. Comparable to a circus tent, it was one hundred yards long and had to be specially made in Columbus.

Fittingly, Kachelmacher means "tile maker." However, it wasn't until October 1908 that the brick plant was in partial operation. It had been delayed by an industrial depression during the previous fall and spring that slowed the arrival of equipment. Several of the employees from Bessie Furnace, which had to be shut down due to a shortage of water, came to work in the brick plant. Kachelmacher founded two conjoined company towns: Kachelmacher (where the plant was located) and Greendale (where the people lived).

Like most businessmen of the era, Kachelmacher spent much of his time in court for one reason or another. In a dispute over ownership of a coal

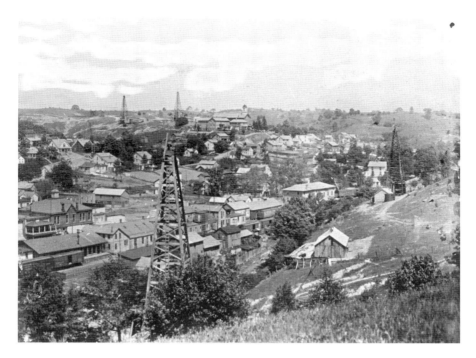

New Straitsville is a shadow of its former self. *Wesley Tharp.*

mine at Buchtel, Kachelmacher found himself indicted for rioting by the local sheriff. His attorneys had advised Columbus & Hocking Coal & Iron Company to take possession of the York Clay & Mining Company. Although there was no violence, several members of the Columbus & Hocking party were found to be carrying weapons.

One year after he opened his brick plant, Kachelmacher resigned from the presidency of the Columbus & Hocking Coal & Iron Company. He told the *Ohio State Journal* that he planned to "take things easy" for the next year. He wanted to have "greater freedom to enjoy the pleasures of life, and in part to have time to give attention to other and more pressing business interests."[107]

Although his impact on the region was undeniable, Kachelmacher remains something of an enigma. He lived in Columbus during his most productive years and, at one time, owned the largest coal yard in the city. But he moved to Logan following his retirement and built an impressive home in what was then regarded as a wilderness. As the county seat of Hocking County, Logan had played mostly a governmental role in the development of the Hocking Valley coal fields. Founded in 1816 by Ohio governor Thomas Worthington, the town benefited first from the opening of the Hocking Canal in 1838

and then the arrival of the Columbus & Hocking Valley Railroad on August 28, 1869. Nearly all of the coal from that region of the state would pass through Logan as it became the junction of three railroads—the mainline from Nelsonville, the Straitsville Branch and the River Division to Pomeroy.

Kachelmacher purchased a large tract of land in "South Logan," planning to create a community of 250 homes and a park. When he died in 1917 at the age of fifty-seven, he left his $2 million estate to the City of Logan, as well as ten acres of land on the south side of the Hocking River for a park named after him. A longtime sufferer from varicose veins, he had created a trust for the Kachelmacher Memorial Clinic, a world-renowned medical facility dedicated "solely to research the cure, prevention and relief of varicose veins."[108] It is a fitting monument to the man who once said, "It is my belief that each person should endeavor to make the world a little better because he lived and worked in it."[109]

# DEATH AND DISASTER

*The life of the dead is placed in the memory of the living.*
—*Marcus Tullius Cicero,* Ninth Oration *(43 BC)*

Around midnight on July 21, 1865, four Trumbull County miners were trapped in a mine operated by the Brookfield Coal Company near the village of Coalburg. A flash flood had formed a subterranean lake, preventing the men from making their way out through the mine's only opening. After seven days of heroic effort, all four workers were saved, but the accident had profoundly shaken the miners throughout the Mahoning Valley.

For much of its history, coal mining was a virtually unregulated activity in Ohio. Miners routinely worked in unsafe conditions. Although they petitioned the state's politicians to enact legislation to protect their lives, it would take more than a close call to make it happen. It would take the Avondale Mine Disaster.

The Avondale Colliery near Plymouth, Pennsylvania, caught fire on September 6, 1869. Once again, there was but one way in or out of the mine. Before it was over, 108 trapped miners had suffocated and two would-be rescuers had also perished. In response to this tragedy, a series of letters began appearing in Ohio newspapers under the name "Jock Pittsbreeks" urging the General Assembly to pass laws to improve mine safety. Better organized this time, the miners put together one committee to draft the bill and another to introduce it. Not only did it call for two separate openings in all mines employing more than ten men underground, but it also included

The Buchtel Mine Disaster as imagined in *Frank Leslie's Illustrated Newspaper*. *Library of Congress.*

provisions for air circulation, daily gas inspections, the appointment of four state mine inspectors and the right of miners to hire a man of their own choosing to ensure that their coal was accurately weighed at the mine tipple.

The mine operators assembled a formidable legal team that managed to muddy the waters by arguing that the bill was being pushed by demagogues and mischief-makers (not miners) and that the mines were not deep enough to be dangerous. By the time the legislation finally passed, it had been stripped of the section calling for inspections. The owners had won—for the moment.

Then, on July 3, 1872, disaster struck in a Portage County mine owned by the Atwater Coal Company of Cleveland. John Hutchins, the company's

president, had personally toured the mine the previous morning and found everything in order. However, like Avondale, the Atwater mine had only one opening, so when a fire broke out, nine men and one boy died and nearly as many were terribly injured. As soon as the fire was discovered, the boy, nine-year-old George Hufford, was ordered into the mine to warn the others by Mr. Strong, who then fled to safety. It was the first mining disaster in the state and the nineteenth in the country involving at least five deaths.

The full bill was once again introduced into the General Assembly in 1874. Judge George Hoadly of Cincinnati, who would later set the bar for incompetence as Ohio governor, argued against it: "I admit that there is a line to which the right of the legislature—the duty of the legislature—may go without infringing on the natural right of the citizen; but what I want to suggest as the safe side, is to leave the people free, and to allow mishap and disaster to have its natural effect as the penalty for and the cure of the evils which result from negligence which causes mishap and disaster."[110] This time, the owners were denied, and as a result, Ohio became the third state to pass a law governing mine safety after Pennsylvania in 1869 and Illinois in 1872.

Over the next fifty years, Ohio would experience a half dozen more mine disasters, totaling sixty-two deaths. The miners mostly fell victim to explosions, fires and suffocation. More often than not, the accident was attributed to a rockslide shorting out an electrical cable and igniting gas fumes. The one exception was the only mine disaster that occurred in the Hocking Valley. On November 3, 1906, an elevator cable snapped in San Toy Number 1, Perry County, and eight men plunged one hundred feet down the mine shaft. Three survived. Compared to the rest of Ohio and many other coal mining states, the Hocking Valley mines had a respectable record when it came to safety. While there had been accidents all along, the loss of life hovered below the "disaster" threshold of five deaths. For example, on June 8, 1900, three men died at Rend's Mine Number 2 in Glouster. But that would change.

By 1930, forty-year-old William G. Ewing Tytus had risen from sales agent to president of the Sunday Creek Coal Company. From his office in Columbus, he oversaw the largest mining operation in eastern Ohio. Along with his wife, Francis, and three children, the eldest of whom was eight, he lived in a comfortable home with two live-in servants on North Parkview Avenue in the well-heeled suburb of Bexley. Born in Middletown, Ohio, in 1890, Tytus had worked his way up in the coal industry. In 1921, he had been hired as sales agent for Sunday Creek Coal, his predecessor having

retired due to ill health. Within eight years, he had become president of the company, which operated thirty-three mines in southeastern Ohio and twenty-seven in West Virginia—one of the largest coal companies in the world. Life was good.

Although the company had given serious consideration to abandoning properties in Ohio as recently as 1928, Tytus continued to invest in them. He had recently installed a new ventilating system in Poston Mine Number 6. On November 5, 1930, he traveled to Millfield, Athens County, to inspect the mine. Among the party of eight was P.A. Coen, vice-president; H.H. Upson, mine superintendent; H.E. Lancaster, chief engineer; Walter Hayden, mine superintendent; Joseph Bergen, superintendent of the Ohio Power Company; Robert Parsons, superintendent of the Columbia Cement Company; and Thomas Trainer, an official with the Pittsburgh Glass Company.

Located one mile east of Millfield in Dover Township, Number 6 was originally opened by Clinton L. Poston and George H. Smith of the Millfield Coal Mining Company. It was then leased to the Poston Consolidation Company in 1911. The following year, the first coal was loaded out of it. In September 1929, the Sunday Creek Coal Company acquired Number 6. Seven months afterward, all regular operations in the mine were halted in order to make needed repairs and improvements. The newly renovated mine was put back into operation on August 11, 1930. With double and triple entryways, Number 6 was regarded as the best and safest mine in all of the Hocking Valley. However, on August 31, 1930, a state mine inspector warned mine officials that too much gas was accumulating in it. He gave the company ten days to resolve the problem—five days too long.

Number 6 was one of the largest mines in the Hocking Valley. Employing more than eight hundred men and operating on double shift, it produced more than five thousand tons of coal every twenty-four hours, five days a week. The coal was then shipped out via the Kanawha & Michigan Railroad. Fifteen minutes before noon on November 5, 1930, an explosion occurred two miles from the main shaft, deep in the mine.[111] It was followed by a tremendous gust of wind that hurled the miners about like dolls. Moments later, they were buffeted by another gust of wind coming from the opposite direction. At first, some of the miners thought the roof had collapsed. However, when they realized the truth, they started moving to safety as smoke began rolling out of the mine. Those who were outside immediately sent out distress calls for medical staff and supplies. They also contacted the Ohio Division of Mines and the U.S. Bureau of Mines, asking for rescue personnel and equipment because they did not have any handy.

They later surmised that a pocket of methane gas that collected in section Six North was ignited by an electrical arc between a fallen trolley wire and the rail, perhaps triggered by slate collapsing from the ceiling. The rail was known to be broken, and the power shouldn't have been on, but for some reason it was. The resulting explosion toppled many of the mine walls, scorched nearby equipment, knocked mine cars off the tracks and twisted beams 760 feet from the main shaft. Men were propelled 100 feet or more through the air. Tytus and his group had entered the mine an hour earlier and had gone about a mile and a half deep. A second blast soon followed due to the ignition of coal dust.

When the blast happened, sixteen-year-old Sigmund Kozma was loading coal with his father and about a dozen others some 550 feet away. Hastily constructing a barricade against the poisonous gas, they began a three-hour ascent up a ventilation shaft. Roughly ten hours after the explosion, a rescue team found nineteen survivors, all but two unconscious, about three miles from the entrance. They had tried to use sheets of burlap, mud and stocks to erect a barricade to protect themselves from carbon monoxide. One man covered his face with his wife's apron, which he had soaked in coffee. All survived.

*Left to right*: Del Guess, unknown and Bob Guess survived the Millfield Mine Disaster. *Wesley Tharp.*

All told, there were some 250 men in the mine that cool, overcast day when the explosion occurred. Many of them were gathered around the hoisting cage in groups of 10, waiting their turn to descend 189 feet down into the main shaft. Nearly 120 escaped, many through ventilation shafts. Those who survived the initial blast and the fire had to contend with the "afterdamp"—the deadly buildup of carbon dioxide, carbon monoxide and nitrogen gas. Distress calls were immediately sent out to Columbus, Nelsonville, Cambridge and Pittsburgh. Red Cross nurses, local doctors, Salvation Army volunteers and others began flooding the area to provide assistance. Within four hours, Chief Inspector W.E. Smith of the United States Bureau of Mines was on site with three inspectors, mine rescue teams and equipment.

Because the mine lost power after the explosion and there was debris on the railroad tracks, a dozen mules were brought in to move wreckage and retrieve bodies. All the while, there was fear that another explosion might occur at any time. The first bodies weren't discovered until after midnight. In all, 82 men had lost their lives: 73 employees, 5 officials and 4 visitors. Only 2 died due to injuries from the blast; the rest succumbed to carbon monoxide. The population of Millfield—about 1,500—had been decimated. What had been described as a typical village in the Hocking Valley was anything but; 59 women were widowed and 154 children left fatherless. In fourteen families, more than one family member was lost; one mother lost 5 sons. Even some of those who were lucky enough to get out alive suffered ill health for years afterward. A room used for storage, a pool hall and a store were converted into temporary morgues.

Four days after the disaster, the mine was free of noxious gases. About three weeks after that, it reopened and continued as a functioning mine until 1945. For all of that time, the miners continued to work in the shadow of the mine's tipple, which stood as a stark reminder of the disaster that had occurred there. A memorial to the men who died in the Millfield Mine Disaster, listing all of their names, was erected in 1975, not far from the mine's smokestack.

Following an investigation, the Ohio State Mining Department concluded that the Sunday Creek Coal Company was in no way responsible for the accident. The state paid for the burial of the victims, allowing $150 per man. Under the workers' compensation laws, the dead miners' dependents received $18.75 per week, with a cap of $6,500. In all, the state paid out a total of $712,391 to the miners and their dependents.

Millfield was the worst mine disaster in Ohio history and would be directly responsible for the passage of mine safety reforms in 1931.

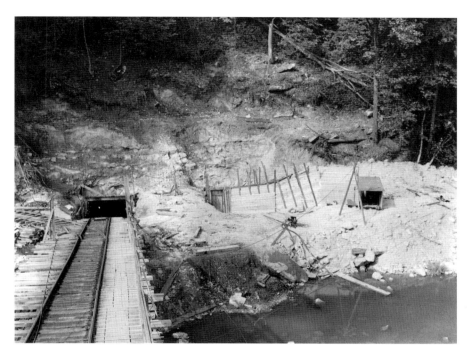

The aftermath of the Powhattan Mine Disaster in 1944. *Columbus Citizen/Citizen Journal Collection.*

Presumably, they did some good, but the record suggests otherwise. Before Millfield closed at the end of World War II, 180 more Ohio miners would die, all in explosions or fires, in just five disasters. Ten years after Millfield, 72 perished in an explosion at Willow Grove Number 10 in St. Clairsville, Belmont County, on March 16, 1940—a mine like Millfield known for its high safety standards, though obviously not high enough. And the Powhatan Mine fire at Bellaire, Belmont County, would claim 66 more on July 5, 1944.

# PAST AND FUTURE

*Even as coal production plunges in the green hills of Appalachia, it is booming in the open-pit mines of Wyoming and under the plains of Illinois and Indiana.*
—*John W. Miller and Rebecca Smith,* Wall Street Journal *(2014)*

In 1906, "F.W.S.," a reporter for the *Coal and Coal Trade Journal*, made a return trip to Columbus, "an important coal trade center."[112] He hadn't visited Ohio's capital for several years, so he wanted to familiarize his readers with "its salient features" vis-à-vis the coal trade. At first glance, the writer noted that it would not be unreasonable to assume that it would take a week to call on every coal company listed in the business directory. However, "the problem becomes much simplified when it is found that from two to six companies have their local habitation in each important office."[113] The owner of, say, four mines would have each name painted on his office door, as well as a fifth name indicating the company selling their product.

For benefit of his readers, F.W.S. described a walking tour of Columbus coal businesses, beginning on Capitol Square at Broad and High Streets. Located at 16 East Broad Street in the Hayden Building were the Middle States Coal Company, the Mohr-Minton Coal Company, the Columbus Coal & Coke Company and the Baltimore & Ohio Coal Company. The adjoining Hayden-Clinton Bank Building at 22–26 East Broad housed the offices of Maynard Brothers (formerly the Columbus & Brush Creek Coal & Coke Company). The Outlook Building at 44 East Broad Street contained the Sunday Creek Coal Company (and its West Virginia

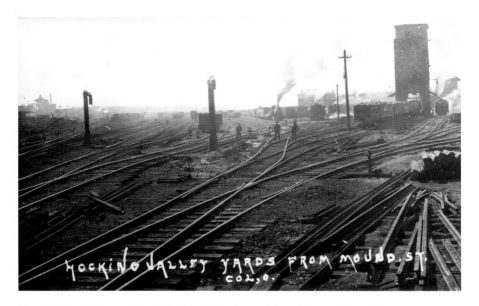

The Hocking Valley Railroad Yard in Columbus at Mound Street. *Bruce Warner.*

subsidiary, Kanawha & Hocking), General Hocking Fuel Company, E.A. Cole & Company and Fobes Tompkins. Next door in the Spahr Building at 50 East Broad Street were the offices of the New Pittsburgh Coal Company and the Johnson CM Company.

Across High Street at 21 West Broad in the Wyandotte Building, once the center of coal activity in Columbus, were the Northern Fuel Company, Darby Coal & Coke Company, Hisylvania Coal Company, the Black Diamond Coal & Coking Company and the McLiesch CM Company. Around the corner at 17 South High Street was the Harrison Building, home of the New York Coal Company. The Columbus & Hocking Coal & Iron Company was found at 33 North High Street in the First National Bank Building. Beyond that, at the northeast corner of High and Long Streets in the Columbus Savings & Trust (aka Atlas) Building was the Eagle Coal & Coke Company. It also included the rooms of the Columbus Coal Club and the Ohio Club, private social organizations to which many of the most prominent coal men in the city belonged.

The Union National Bank Building on the southeast corner of Spring and High Streets contained the Columbia Fuel Company. A block beyond that, in the Schultz Building at 232 North High Street, were the W.I. Hamilton Coal Company, the Washington Fuel Company, the War Eagle Fuel Company and the Columbus C&M Company. Mention is also made of

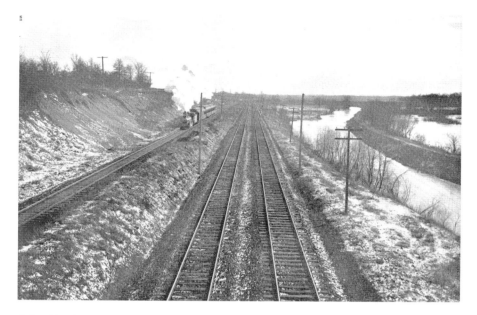

*Left to right*: Heading south out of Columbus are the Toledo & Ohio Central Railroad, the Hocking Valley Railroad, the Columbus Feeder Canal and the Scioto River. *Bruce Warner.*

the Hamilton Company, a new concern. In addition, Columbus was home to the Jeffrey Manufacturing Company, perhaps the most important maker of mining machinery and supplies. The point was this: the coal industry had a definite presence in Ohio's capital.

F.W.S. concluded his tour by stating, "Columbus is probably the only large city in the United States where the retail coal trade has decreased in volume in recent years."[114] The reason? The abundance of natural gas. It had even attracted the interest of veteran coal man Henry D. Turney, who had invested heavily in it, believing that the outlook for natural gas was good for years to come. When the Columbus & Hocking Coal & Iron Company went into receivership in 1910, the company owned 13,000 acres of land in Athens, Hocking, Perry and Vinton Counties, leased the mineral rights for another 250 acres. It also was operating fourteen coal mines, four blast furnaces, a brick plant and several towns. Just the previous year, the company had birthed a subsidiary—Columbus & Hocking Oil & Gas Company—to drill for oil and gas.

The golden age of coal mining in Ohio extended from the Civil War to the Great Depression. It was spurred by the building of the railroads and then by the development of mechanical mining equipment. Coal production

spiraled upward throughout World War I, reaching a peak in 1918, when more than fifty thousand Ohioans were working in the industry. And then the wheels came off. It was already in a slump when the Great Depression further crippled the economy. It wasn't until after World War II that coal mining began to pick back up. But by then, Ohio was switching from below-ground to above-ground mining. The world's largest dragline mining shovel, the twenty-two-story-tall Big Muskie, was erected in southeast Ohio. Its single bucket could hold two Greyhound buses, side by side. While strip mining continues in some parts of Ohio, the Big Muskie is no more, having been disassembled in a gesture to environmental activists who wanted to ensure it would never again be used to ravage the countryside.

In the twenty-first century, the face of coal in Columbus is American Electric Power. Its General Gavin Power Station in Cheshire, Gallia County, is the largest coal-fired facility in Ohio and one of the largest in the nation, responsible for 66 percent of AEP's power generation. However, AEP got out of the coal mining business in 2004, when it sold its remaining operations in Ohio and Kentucky. Similarly, Columbus-based Boich Companies has also dispensed with its mine holdings and now concerns itself strictly with marketing coal. There are no more coal barons to be found in the capital city. You have to go to Cleveland, where Robert Murray, owner of Murray Energy Corporation and sometimes called the last of the coal barons, still controls 62 percent of Ohio's coal production.

There are many who believe (or hope) that coal has had its day and believe that its continued usage is irresponsible and, possibly, suicidal. Prior to taking office, President Barack Obama told the editorial board of the *San Francisco Chronicle*, "If somebody wants to build a coal plant, they can—it's just that it will bankrupt them, because they are going to be charged a huge sum for all that greenhouse gas that's being emitted." He placed a moratorium on new coal leases on federal lands in an attempt to drive the economy toward so-called "clean energy." But despite this "war on coal," the humble rock continues to hang around eight years later. Much to the dismay of environmentalists, coal fueled 69 percent of Ohio's net electricity generation in 2013. Despite efforts to tax and regulate it out of existence, the state's coal industry refuses to die. There are still some ninety coal mining operations dotting fifteen eastern counties of the state and generating well over $500 million annually.

But in the Hocking Valley, many abandoned mines fester like open wounds. From this largely uncharted labyrinth of shafts and tunnels, poisonous minerals bleed into the creeks and rivers, giving them an orange

tint that betrays acid mine drainage. An estimated 340 miles of southeastern Ohio waterways have been polluted in this fashion. While the orange color is caused by iron, high levels of aluminum will turn the water white and manganese will color it black.

In the Monday Creek Watershed, which covers 116 miles of Athens, Hocking and Perry Counties, scientists and volunteers are working diligently to reclaim the streams. The goal is to reduce their acidity to acceptable levels so that they will be hospitable to fish and other aquatic lifeforms. But it is an immense and expensive undertaking.

Simultaneously, a handful of nonprofit groups have formed to document and preserve the history of the mining communities. The best known is Shawnee-based Sunday Creek Associates, which has done much to unite and promote the region under the banner of the Little Cities of Black Diamonds Council. It was able to save the historic Tecumseh Theater from the wrecking ball and has begun restoring it to its former glory. However, time is working against the organization when it comes to saving the other historic buildings to be found in Shawnee.

Formed in the 1970s, the New Straitsville History Group operates the New Straitsville History Museum just below Robinson's Cave. Like Shawnee, New Straitsville was known for its "boomtown" architecture, with many buildings sporting distinctive second-floor porches that projected out over the sidewalk. These, too, have all but disappeared.

Working closely with the Baird Foundation, a group of dedicated volunteers toiled for the best part of three decades to restore and reopen Stuart's Opera House in Nelsonville. It has since become one of the premier concert venues in southeastern Ohio and hosts the annual Nelsonville Music Festival.

Built by the Hocking Valley Coal Company between 1900 and 1902, Hocking was a typical, small company town. It was originally operated by the Johnson brothers and sat atop Mine Number 4, one of several mines in the area. The mine closed in the early 1930s but reopened from 1940 to 1948 as part of America's war effort. Its last superintendent, E.A. Cottingham, acquired ownership of the store and houses and rented them out until he passed away. His daughter, Virginia Gamertsfelder, subsequently sold them to a group of five friends in 1997. They renamed the town Eclipse and set about restoring the remaining buildings for commercial uses.

The Haydenville Preservation Committee was dedicated to saving as much of "Ohio's Last Company Town" as it could, but the task was an enormous and costly one. Without a financial "angel" on the order of the

Miners leaving the Peabody mine at New Lexington in 1984. *Columbus Citizen/Citizen Journal Collection.*

Baird Foundation or a group of friends like those who adopted Hocking, there is little hope that Haydenville will be saved.

All of these efforts and more need your support. Julia Rocchi of the National Trust for Historic Preservation has listed six reasons for preserving old buildings: quality, potential, preference, popularity, cultural awareness and irreplaceability.[115] But what it really comes down to is this: when they're gone, they're gone.

The Hocking Valley is like an aging fighter: battered, bruised and bloodied but still standing. So don't count it out quite yet. It just might have a few more rounds in it. And there are still "diamonds" to be found if you know where to look.

# AFTERWORD

*The blaze is an inferno and the draft forces the flames nearly 100 feet and it can been seen for miles along the hills, resembling a volcano.*
—Coal Trade Bulletin *(1918)*

Nearly 35 years after it was set, the mine fire at New Straitsville continued to rage out of control, playing a deadly game of hide-and-seek, disappearing underground for a time and then popping up unexpectedly in someone's backyard. Fissures would open up, and flames would spout nearly one hundred feet into the air. Notoriously difficult to extinguish, mine fires have been known to burn for years. However, at more than 130 years and counting, the New Straitsville mine fire is, unquestionably, the "World's Greatest Mine Fire" (as it was once billed).

With a seemingly unlimited amount of fuel and no real tactical location for firefighters to work from, even those mine fires caused by natural means, such as lightning strikes, are left burning for years. It is estimated that worldwide there are more than one thousand currently active, although real numbers are hard to find, since many occur in undeveloped and recently industrialized countries where the governments either cannot or will not report them.

Despite the obvious danger, the New Straitsville fire became a tourist attraction for a short time, as people flocked to Perry County. There were competing tour companies, and the *Ripley's Believe It or Not* radio show originated a broadcast from the town. Famed journalist Ernie Pyle reported

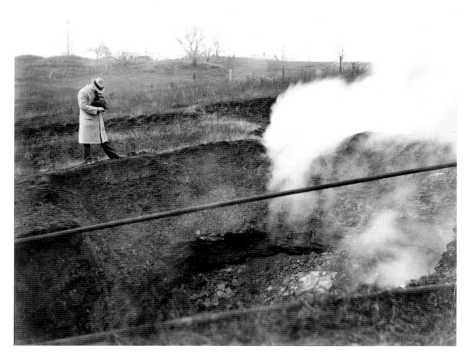

Dynamite failed to extinguish the fire in 1937. *Columbus Citizen/Citizen Journal Collection.*

on the phenomenon for NBC Radio and also in his syndicated newspaper column. Over the years, many residents had to be relocated as the ground collapsed under buildings and roadways. Potatoes were already baked when dug out of the earth, roses bloomed during the winter and eggs could be cooked over smoking fissures in the ground. Despite repeated efforts to keep the fire in check, it continued its relentless march beneath the soil. Finally, in the 1930s, much of the affected land was incorporated into the Wayne National Forest.

The New Straitsville fire has been eclipsed in popular culture by a more recent one in Centralia, Pennsylvania. It began late in May 1962, after the volunteer fire department had begun cleanup on a recently moved landfill, now located precariously next to an abandoned strip mine pit and, for the benefit of ghost story enthusiasts, the Odd Fellows Cemetery. The Independent Order of Odd Fellows, a fraternal organization that originated in England, was so called because it admitted men of all social castes, from nobility to the working class—even women.

The firemen unwittingly set the landfill ablaze, as they had in previous years at its earlier location, despite the extralegal nature of this sort of

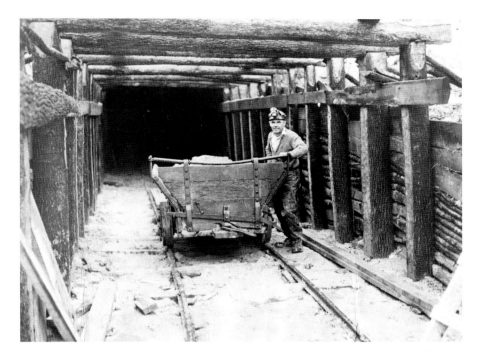

Three barriers were dug in an attempt to halt the fire. *Columbus Citizen/Citizen Journal Collection.*

controlled burn. This time, the fire quickly spread to the coal pit and then down into the abandoned mine tunnels under the town. Or so some claim. Another theory states that there was a second fire, started by an individual seeking to burn his own trash. Then there is the possibility that an earlier fire in 1932 might not have been properly extinguished.

Although the coal boom was over, about two hundred people still lived in Centralia. After the fire, many left, but many more elected to stay, despite the increasing public health hazard. In 1984, a coordinated voluntary evacuation effort was put into place to move residents. When the state declared eminent domain, some Centralians sued for the right to remain. The federal government revoked that ZIP code and closed the post office. The neighboring town of Byrnesville was also evacuated. In 2013, the remaining eight residents won the opportunity to remain in their homes until their deaths, but no new residents may move in due to the heavy air pollution.

The Centralia fire became the basis for books, ghost stories, urban legends and the *Silent Hill* series of video games and movies, as well as at least one theme park ride. It may also have inspired the deeply disturbing Chevy Chase comedy *Nothing but Trouble*.

# AFTERWORD

By comparison, New Straitsville could still boast 722 residents in the 2010 census, a decrease of about 50 over the previous decade. And it hosts an annual Moonshine Festival—the distilling of moonshine being another chapter from the community's colorful history. Meanwhile, rumors persist that some residents still have the convenience of making coffee with well water drawn directly from the kitchen faucet because it always runs hot.

ELISE MEYERS WALKER

# WORKERS AND BOSSES

In the development of the Hocking Valley coal fields, there were many workers and bosses who led the way. Following are a few of the more prominent ones, many of whom were buried in Columbus.

| Name | Born | Place | Died | Place | Cemetery |
|---|---|---|---|---|---|
| Samuel Baird | 1825 | Brush Creek, Adams County, OH [speculative] | November 3, 1877 | Monday Creek, OH | Greenwood, Zanesville, OH |
| William Barker Brooks | October 31, 1819 | Castine, ME | June 5, 1896 | Columbus, OH | Green Lawn, Columbus, OH |
| Solomon Churchill | July 19, 1834 | South Point, OH | April 21, 1886 | Columbus, OH | Woodlawn, Zanesville, OH |
| Walter Crafts | January 21, 1839 | West Newton, MA | August 2, 1896 | Pittsburgh, PA | Newton, Newton, MA |
| Richard L. Davis | December 24, 1864 | Roanoke, VA | January 10, 1900 | Rendville, OH | Rendville, Rendville, OH |
| William G. Deshler | May 24, 1827 | Columbus, OH | February 16, 1916 | Columbus, OH | Green Lawn, Columbus, OH |
| Henry Beecher Dierdorff | January 29, 1851 | Seville, OH | January 26, 1935 | Columbus, Upper Arlington, OH | Green Lawn, Columbus, OH |
| Levi Rinehart Doty | April 22, 1847 | Springfield, OH | December 21, 1911 | Chicago, IL | Green Lawn, Columbus, OH |
| Christopher Evans | March 8, 1841 | England | October 2, 1924 | Nelsonville, OH | New Straitsville Joint, New Straitsville, OH |
| Washington Gladden | February 11, 1836 | Pottsgrove, PA | July 2, 1918 | Columbus, OH | Green Lawn, Columbus, OH |
| Milbury Miller Greene | May 11, 1830 | Lewiston Falls, ME | June 26, 1887 | Columbus, OH | Green Lawn, Columbus, OH |

| Name | Born | Place | Died | Place | Cemetery |
|---|---|---|---|---|---|
| Peter Hayden | September 15, 1806 | Onondoga, NY | April 6, 1888 | Manhattan, NY | Green Lawn, Columbus, OH |
| Joseph Andrew Jeffrey | January 17, 1836 | Clarksville, Clinton County, OH | August 27, 1928 | Bexley, OH | Green Lawn, Columbus, OH |
| William Job | 1843 | England | April 16, 1931 | Roxbury, MA | Massachusetts [speculative] |
| Niles Kachelmacher | August 8, 1860 | Tonsberg, Norway | July 5, 1917 | Logan, OH | Kachelmacher Park, Logan, OH |
| Francis Marion Lechner | August 16, 1838 | Waynesburg, OH | January 30, 1915 | Columbus, OH | Green Lawn, Columbus, OH |
| Thomas L. Lewis | July 25, 1865 | Locust Gap, PA | May 1, 1939 | Charleston, WV | Riverview, Martin's Ferry, OH |
| William Thomas Lewis | March 27, 1861 | Wales | April 28, 1909 | Cleveland, OH | Green Lawn, Columbus, OH |
| Thaddeus Longstreth | December 13, 1843 | Lebanon, OH | October 12, 1904 | Columbus, OH | Green Lawn, Columbus, OH |
| John D. Martin | January 7, 1819 | Greencastle, Fairfield County, OH | December 7, 1898 | Lancaster, OH | Forest Rose, Lancaster, OH |
| John McBride | June 25, 1854 | Wayne County, OH | October 9, 1917 | Globe, AZ | Green Lawn, Columbus, OH |
| Thomas Pirt | August 30, 1841 | Craulington, Northumberland, England | March 24, 1899 | Columbus, OH | Green Lawn, Columbus, OH |

| Name | Born | Place | Died | Place | Cemetery |
|---|---|---|---|---|---|
| Clinton L. Poston | November 19, 1847 | Athens County, OH | August 23, 1923 | Athens, OH | West Union Street, Athens, OH |
| Elias McClellan Poston | October 26, 1862 | Nelsonville, OH | October 9, 1931 | Columbus, OH | Green Lawn, Columbus, OH |
| Lorenzo Dow Poston | March 22, 1812 | Hampshire County, VA | December 16, 1875 | Nelsonville, OH | Greenlawn, Nelsonville, OH |
| William P. Rend | February 10, 1840 | County Leitrim, Ireland | November 30, 1915 | Chicago, IL | Calvary, Cook County, Evanston, IL / Mount Carmel, Hillside, Cook County, IL [116] |
| Ida Mae Stull | February 2, 1896 | Harrison County, OH | April 23, 1980 | Cadiz, OH | Cadiz Union, Cadiz, OH |
| James H. Taylor | May 3, 1825 | Harrison Township, Perry County, OH | January 25, 1891 | Perry County, OH | New Lexington, Perry County, OH |
| Samuel Thomas | April 27, 1840 | South Point, OH | January 11, 1903 | New York, NY | Sleepy Hollow, Westchester, NY |
| Henry Denny Turney | July 10, 1852 | Circleville/ Springfield, OH | February 8, 1931 | Sarasota, FL | Forest, Circleville, OH |
| William G. Ewing Tytus | April 17, 1890 | Middletown, OH | November 5, 1930 | Millfield, Athens County, OH | Woodside, Middletown, OH |
| Charles H. Welch | April 16, 1833 | Rochester, NY | March 17, 1914 | Columbus, OH | Green Lawn, Columbus, OH |

# COME ALL YOU
# JOLLY MINERS

In the midst of the Black Diamond War, the following verses, attributed to an "old Miner," were published in the *Jackson (OH) Standard*. Based on the traditional Irish "Come-All-Ye" ballad format, it is a song-poem that was likely intended to be sung to a popular folk tune.

*Come all you Jolly Miners*
*Wherever you may be,*
*I pray you give attention*
*And listen unto me.*

*The fate of we poor Union men,*
*As some people know;*
*For six months out of work my boys*
*And never struck a blow.*

*We Miners wanted nothing,*
*But what was honest and right;*
*The bosses wouldn't give it,*
*But got the niggers for to fight.*

*They came to Hocking Valley,*
*As it is told to me:*
*They marched them down to Longstreth's mines*
*Which I did plainly see.*

*They placed the muskets in their hands,*
*With powder and some ball;*
*To fire at the Union men,*
*If they did anything at all.*

*But the Union men they was not rough*
*But walked with a will;*
*They marched up and down the streets,*
*And back to Nelsonvllle.*

*The Operators will not pay,*
*The fair and honest thing;*
*But turn against the Union men.*
*And fetch the niggers in.*

*So pity we poor Union men.*
*That in the Valley stay;*
*For we do our best and that you know,*
*To send the niggers away.*

*But the bosses they are to blame,*
*And that you all do know;*
*For encroaching on we Union men,*
*And bring our wages low.*

*For the darkies they have come sir,*
*And that you all do know;*
*To take the place of white men.*
*And him to overthrow.*

*So pity we poor miner.*
*That works all underground:*
*All up and down the Valley,*
*And through to Shawnee town.*

*There's Thomas Pirt, the President,*
*Of the Union men, you know;*
*Likewise Sunderland, Secretary,*
*Which the bosses wants to overthrow.*

*They still encourage the Union men,*
*That I can plainly see;*
*They are as brave and upright men,*
*As ever crossed the sea.*

As Ivan Tribe has documented, a miner from Glouster, J. McInaw, wrote "The Hocking Leader's Address" and "The Hocking Strike" in 1885. Joseph Siemer, a miner from Corning, contributed "After the Strike" in 1894.

# NOTES

## Introduction

1. Stille, *Ohio Builds a Nation*.
2. Harden, "Time to Fund Ohio Artisan Center."

## Chapter 1

3. Martin, *History of Franklin County, Ohio*.
4. Lentz, *Columbus*.
5. Lee, *History of the City of Columbus*.
6. The letter was dated November 20, 1824, three years before Betsy Deshler would die of malaria at the age of thirty.
7. For at least 5,500 years, man has been producing charcoal by slowly heating wood in a low-oxygen environment to drive out all of the impurities from the carbon char.
8. Jeremiah Munson, a veteran of the War of 1812, constructed a charcoal-fired furnace for producing cast iron—re-smelted pig iron—by what is now Granville's Maple Grove Cemetery in 1816. It was abandoned in 1838.
9. Built by David Moore along Rocky Fork Creek in 1816 and named for his wife, Mary Ann Furnace burned down in 1850.
10. Lee, *History of the City of Columbus*.
11. A bench is a level of coal separated by slate.
12. When the lateral canal from Circleville to Columbus opened, the first boats carried coal for the Gill foundries.

13. Dickens learned of an instance of spontaneous human combustion while visiting Columbus, a subject incorporated into his 1853 novel, *Bleak House*. As he wrote in the preface, "Another case, very clearly described by a dentist, occurred at the town of Columbus, in the United States of America, quite recently. The subject was a German who kept a liquor-shop and was an inveterate drunkard."

14. Cummington is located at the foot of the Berkshires, which is generally given as his birthplace.

15. It wasn't until 1889 that the legislature actually made any substantive changes in the practice.

16. The best roads were paved with gravel or planking, but most were simply clay or dirt and often impassable during the winter and spring.

17. *Calcutta (India) Review*, "Coal Resources of Bengal."

18. Lee, *History of the City of Columbus.*

19. Presumably this referred to the bituminous coal mined in Washington County, Pennsylvania, which was superior to lignite but inferior to anthracite.

# CHAPTER 2

20. A graduate of Ohio University, Clinton Poston bequeathed his home to his alma mater, and it is now the residence of the school's president.

21. This would later be the site of Dr. Samuel Hartman's Peruna Drug Manufacturing Company.

22. John Hunt Morgan's raiders would burn and sink several of these boats during their Civil War raid through Ohio.

23. "During one of the bitter mining strikes of his day [Brooks] was warned on the train of a mob at Nelsonville, waiting with a rope to hang him. Repeated telegrams urging his return to Columbus were quietly ignored; finally the conductor asked what more he could do to prevent the encounter. Mr. Brooks answered: "Why, go ahead! They can't have any fun till I get there!" There were no other passengers on his end of the car when it arrived at Nelsonville; the other end was crowded, but no cooler. Alone he faced and passed through the 'Reception Committee' and its noisy backers, denouncing them as cowards. In the critical hush of the moment no man had the hardihood to touch him." Quoted from *Fuel Magazine*, "Pioneers in the Western Coal Industry."

24. *Athens Messenger*, "Obituary of Elias Poston, Industry Leader."

25. Israel Dille, Dr. John J. Brice and David Moore were members of the Licking County Colonization Society, as were many abolitionists, advocating the "repatriation" of free blacks back to Africa.

26. David Moore had built the earlier Mary Ann Furnace.

## CHAPTER 3

27. The Olentangy River merges with the Scioto River just south of Spring Street, surrendering its identity. But not for the first time. When the Ohio General Assembly passed an act in 1833 to restore the Native American names for the state's waterways, it made a mistake; it should have been called the Keenhongsheconsepung.
28. When Greene passed away at the age of fifty-seven, he left a fortune of $600,000.
29. Tribe, "Pride and the Golden Age of Coal."

## CHAPTER 4

30. Martzolff, *History of Perry County, Ohio.*
31. The United States used to experience fairly regularly financial "panics," the most famous of which was the stock market crash of 1929, which signaled the start of the Great Depression. However, there were fairly serious crashes in 1819, 1837, 1873, 1901 and 1907 as well, each lasting several years.
32. The original Straitsville was soon dubbed Old Straitsville.
33. Gibson, *Photographic History of New Straitsville, O.*
34. Ibid.
35. Davies, *Main Street Blues.*

## CHAPTER 5

36. Everhart, *History of Muskingum County, Ohio.*
37. The Nickel Plate Railroad was built for the sole purpose of selling it off by threatening Vanderbilt's attempt to create a railway monopoly. General Thomas was the Nickel Plate's attorney.
38. Brison, *Rockefeller, Carnegie and Canada.*

## CHAPTER 6

39. Tribe, "John Richards Buchtel."
40. Ibid.
41. Ibid.
42. Vess, "History of Moxahala."
43. *American Republican and Baltimore (MD) Daily Clipper,* "Miraculous Escape."

## CHAPTER 7

44. This was similar to the founding of Federated Department Stores. See Meyers, Meyers and Walker, *Look to Lazarus.*
45. *Biographical Cyclopedia and Portrait Gallery of Representative Men of the State of Ohio.*

## CHAPTER 8

46. Tebben, "Columbus Mileposts."
47. A chain-driven revolving cutter bar with rigid, sharp teeth was placed against the coal face, and a compressed-air engine drove it forward into the coal.
48. *Black Diamond*, "Going Back Into Mining History."
49. *National Police Journal* 2, no. 1 (April 1918).
50. Lovelace, "Shaping Columbus."
51. When Charles H. Welch passed away in 1914 after thirty-seven years of service, the Jeffrey Manufacturing Company closed down for one day in his memory.
52. It wasn't just union members doing the damage. Many inventions, from movie cameras to cash registers, were deliberately sabotaged by rival manufacturers trying to protect their markets.
53. *Springfield (OH) Globe-Republic*, "Hocking Valley Trouble."
54. *Independent Electric Company v. Jeffrey Manufacturing Company et al., Congressional Edition.*

## CHAPTER 9

55. Crowell, *History of the Coal-Mining Industry in Ohio.*
56. Ibid.
57. Ibid.
58. Rick Smith Show, "Women in the Coal Mines? Yes!"
59. Our History and Genealogy, "Southeastern Ohio Coal Industry and History."
60. Lashey and Holt, *Cold Outhouses and Kerosene Lamps.*
61. Crowell, *History of the Coal-Mining Industry in Ohio.*
62. Ibid.
63. Ibid.
64. Ibid.
65. Schnapper, *American Labor.*

## Chapter 10

66. Lewis, *Black Coal Miners in America*.
67. Nelson, *Buckeye Hill Country*.
68. Wheeler, "Allensworth."
69. *Hocking (OH) Sentinel*, December 9, 1897.
70. Ibid.
71. *Highland (County, OH) Weekly News*, "Hayden Sends for Chinamen."
72. Powell, *Against the Tide*.
73. *United Mine Workers' Journal* (May 19, 1899).

## Chapter 11

74. Mark Hanna became William McKinley's biggest supporter, helping him to become president of the United States.
75. Roy, *History of the Coal Miners of the United States*.
76. *Stark County (OH) Democrat*, "New Straitsville."
77. Lewis, *Black Coal Miners in America*.
78. Skrabec, *William McKinley*.

## Chapter 12

79. Howe, *Historical Collections of Ohio*.
80. Roy, *History of the Coal Miners of the United States*.
81. *New York Times*, "Soldiers at the Mines."
82. *Milwaukee (WI) Journal*, "Riotous Coal Miners."
83. *Executive Documents: Annual Reports for 1884*.
84. Meyers and Walker, *Wicked Columbus, Ohio*.
85. Ohio Memory, "Hocking Valley Strike Telegrams."
86. Roy, *History of the Coal Miners of the United States*.
87. *Daily Cairo (IL) Bulletin*, "Monopoly's Handiwork."
88. Our History and Genealogy, "Southeastern Ohio Coal Industry and History."
89. Gladden, *Recollections*.

## Chapter 13

90. Granville, *Proceedings of the Hocking Valley Investigation Committee*.
91. Ibid.
92. Ibid.
93. Ibid.

94. Olcott, *Life of McKinley.*
95. "During the recent strike in the coal regions a Hocking Valley coal train was stopped by strikers about a quarter of a mile from a wooden bridge. The leader of the strikers told the engineer that he must not pull that train through and the engineer declared that he would. 'Come down, Jim!' cried one of the strikers. 'We know you too well to harm you. We have a key of powder on that bridge, and when the boys see you coming, they are going to light the fuse.' 'All right,' replied the engineer, grimly. 'I've promised to pull this train through, and through she goes.' With these words he opened the throttle and the train dashed on. The strikers saw the train coming and lit the fuse. On and over the bridge the train went; as the last car cleared the structure bang! went the powder, and the bridge was blown to splinters. The fuse was a quarter-inch too long." Quoted from *(Hillsboro, OH) News-Herald*, "Brave Engineer."

## Chapter 14

96. Fallows, *Life of William McKinley.*
97. Allowing for inflation, $1,000 in 1895 is equal to about $29,000 today.
98. Phillips, *William McKinley.*
99. Lewis, *Welsh Americans.*
100. Ibid.
101. George, "Coal Miners' Strike of 1897."
102. *(Cincinnati, OH) Labor Advocate*, "Buy Ohio Coal."

## Chapter 15

103. Zuefle, "I Reckon…San Toy."
104. Downs, "Exploring a Ghost Town."
105. A tipple was a structure used to load the coal into canalboats, railroad hopper cars or trucks for transport.
106. *Athens (OH) Messenger*, "Miners at Santoy Will Not Be Evicted."
107. *(Logan, OH) Democrat-Sentinel*, "Kachelmacher Resigns."
108. Williams, "Historical Marker Dedication."
109. *Logan (OH) Daily News*, "Varicose Veins Research Foundation."

## Chapter 16

110. Bruere, *Coming of Coal.*
111. Mine gases were called damps (from the Lower German word *dampf*, meaning "vapor"). Explosive or flammable gases such as methane and

other hydrocarbons were firedamps. Carbon monoxide was called white damp. Black damp, also called choke damp, was a mixture of nitrogen and carbon dioxide that cause suffocation. After damp was a mixture of gases that was produced by explosions. And stink damp was a smelly gas, usually hydrogen sulfide, which was the only one easily detected. Miners had to be ever vigilant for damps because they all were potentially deadly.

## CHAPTER 17

112. *Coal and Coal Trade Journal*, "Columbus Observations."
113. Ibid.
114. Ibid.
115. Rocchi, "Six Practical Reasons to Save Old Buildings."

## APPENDIX I

116. There are monuments in two different cemeteries.

# SELECTED BIBLIOGRAPHY

## NEWSPAPERS AND PERIODICALS

*Albuquerque (NM) Daily Citizen*
*American Republican and Baltimore (MD) Daily Clipper*
*Athens (OH) Messenger*
*Black Diamond*
*Bulletin of the American Iron and Steel Association*
*(Cheboygan, MI) Northern Tribune*
*Chicago (IL) Tribune*
*Coal and Coal Trade Journal*
*Columbus (OH) Dispatch*
*Coshocton (OH) Tribune*
*Daily (Columbus) Ohio State Journal*
*Dallas (TX) Daily Herald*
*Dayton (OH) Daily News*
*Dayton (OH) Journal Herald*
*Fairmont West Virginian*
*Hocking (Logan, OH) Sentinel*
*Iron Trade Review*
*Jackson (OH) Standard*
*Kingsport (TN) Times*
*(Logan, OH) Democrat-Sentinel*
*(Logan) Ohio Democrat*
*Mahoning (County, OH) Dispatch*
*Marshall County (IN) Independent*

*(Maysville, KY) Evening Bulletin*
*Memphis (TN) Daily Appeal*
*Milwaukee (WI) Journal*
*(Milwaukee, WI) Weekly*
*Minneapolis (MN) Journal*
*(Napoleon, OH) Democratic Northwest*
*New Lexington (OH) Herald*
*New York (NY) Times*
*"Old Northwest" Genealogical Quarterly*
*Perrysburg (OH) Journal*
*Rock Island (IL) Daily Argus*
*Sacramento (CA) Daily Record-Union*
*Sandusky (OH) Register*
*San Francisco (CA) Call*
*Springfield (OH) Globe-Republic*
*Stark County (OH) Democrat*
*Steubenville (OH) Herald-Star*
*St. Louis (MO) Republic*
*(Washington, D.C.) Evening Star*
*Wheeling (WV) Daily Intelligencer*
*World To-day*

## BOOKS AND ARTICLES

Addington, "Shorty." *San Toy: The Town that Ain't No More*. McConnelsville, OH: Morgan County Historical Society, 1987.

*American Republican and Baltimore (MD) Daily Clipper.* "Miraculous Escape." December 2, 1845.

*Athens (OH) Messenger.* "Miners at Santoy Will Not Be Evicted." April 15, 1927.

———. "Obituary of Elias Poston, Industry Leader." October 9, 1931.

*Biographical Cyclopedia and Portrait Gallery of Representative Men of the State of Ohio.* Cincinnati, OH: Western Biographical Publishing Company, 1891.

*Black Diamond* 62. "Going Back Into Mining History" (May 10, 1919).

Brison, Jeffrey D. *Rockefeller, Carnegie and Canada*. Montreal, CA: McGill-Queen's University Press, 2005.

Bruere, Robert W. *The Coming of Coal*. New York: Association Press, 1922.

*Bulletin of the American Iron and Steel Association* 20. "In Memory of Solomon Churchill" (May 12, 1886). Philadelphia, PA.

*Bulletin of the Industrial Commission of Ohio: Statistics of Mines and Quarries in Ohio 1917* 5, no. 2 (November 8, 1918).

*Calcutta (India) Review* 12. "Coal Resources of Bengal" (July–December 1849).

# SELECTED BIBLIOGRAPHY

*Catholic Record Society Diocese of Columbus Bulletin.* "Chapel Hill, Perry County, Ohio" (February 1977).

*(Cincinnati, OH) Labor Advocate.* "Buy Ohio Coal." September 25, 1915.

*Coal and Coal Trade Journal.* "Columbus Observations" (January 31, 1906).

Crowell, Douglas L. *History of the Coal-Mining Industry in Ohio.* Columbus: Ohio Department of Natural Resources, 1995.

*Daily Cairo (IL) Bulletin.* "Monopoly's Handiwork." December 10, 1884.

Davies, Richard O. *Main Street Blues: The Decline of Small-Town America.* Columbus: Ohio State University Press, 1998.

Downs, M. "Exploring a Ghost Town." *(Zanesville, OH) Times Recorder*, April 8, 2002.

Evans, Christopher. *History of the United Mine Workers of America.* Indianapolis, IN, 1918–20.

Everhart, J.F. *History of Muskingum County, Ohio.* Columbus, OH: J.F. Everhart & Company, 1882.

*Executive Documents: Annual Reports for 1884.* Columbus, OH: Westbote Company, 1885.

Fallows, Bishop Samuel. *Life of William McKinley, Our Martyred President.* Chicago, IL: Regan Printing House, 1901.

*Fuel Magazine: The Coal Operators National Weekly.* "Pioneers in the Western Coal Industry" (February 8, 1910).

George, J.E. "The Coal Miners' Strike of 1897." *Quarterly Journal of Economics* 12, no. 2 (January 1898).

Gibson, R.M. *History of Shawnee, Ohio.* Columbus, OH: Selby Publishing & Printing, 1900.

———. *Photographic History of New Straitsville, O.* Pamphlet, New Straitsville, OH, 1907.

Gladden, Washington. *Recollections.* Boston, MA: Houghton Mifflin Company, 1909.

Graham, A.A. *History of Fairfield and Perry Counties, Ohio: Their Past and Present.* Chicago, IL: W.H. Beers & Company, 1883.

Granville, Algernon. *Proceedings of the Hocking Valley Investigation Committee.* Columbus, OH: Westbote Company, 1885.

Gutman, H.G. "Reconstruction in Ohio: Negroes in the Hocking Valley Coal Mines in 1873 and 1874." *Labor History* 3, no. 3 (1962).

Harden, Mike. "Time to Fund Ohio Artisan Center." *Columbus (OH) Dispatch*, April 27, 2006.

Hayes, Ben. *San Toy: A Ghost Town in the Hocking Valley Coal Fields.* Columbus: Ohio Folklore Society, 1959.

*Highland (County, OH) Weekly News.* "Hayden Sends for Chinamen." March 14, 1872.

*(Hillsboro, OH) News-Herald.* "Brave Engineer, A." November 1, 1894.

*History of Hocking Valley, Ohio.* Chicago, IL: Inter-State Publishing Company, 1883.

*Hocking (OH) Sentinel.* December 9, 1897.

Howe, Henry. *Historical Collections of Ohio.* Cincinnati, OH: C.J. Krehbiel & Company, 1907.

Hunt, Thomas Sterry. *Coal and Iron in Southern Ohio: The Mineral Resources of the Hocking Valley.* N.p.: Nabu Press, n.d.

*Independent Electric Company v. Jeffrey Manufacturing Company et al. Congressional Edition,* vol. 3701 (1898).

Jeffrey, Robert H. "Tad," II. "Jeffrey's Manufacturing History in Columbus." Address before the Columbus Historical Society, Columbus, Ohio, on September 26, 2002.

Lashey, Bob, and Sallie Holt. *Cold Outhouses and Kerosene Lamps.* Hickory, NC: Hometown Memories Publishing Company, 2009.

Lee, Alfred E. *History of the City of Columbus, Capital of Ohio.* Vol. 1. New York: Munsell & Company, 1892.

Lentz, Ed. *Columbus: The Story of a City.* Charleston, SC: Arcadia Publishing, 2003.

Lewis, Ronald L. *Black Coal Miners in America.* Lexington: University Press of Kentucky, 2009.

————. *Welsh Americans: A History of Assimilation in the Coalfields.* Chapel Hill: University of North Carolina Press, 2008.

*Logan (OH) Daily News.* "Varicose Veins Research Foundation Provided Under Kachelmacher Will." June 30, 1939.

*(Logan, OH) Democrat-Sentinel.* "Kachelmacher Resigns." November 4, 1909.

Lovelace, Craig. "Shaping Columbus: Joseph A. Jeffrey, Columbus's Coal-Mining King." *Business First* (February 24, 2012).

Martin, William T. *History of Franklin County, Ohio.* Columbus, OH: Follett, Foster & Company, 1858.

Martzolff, Clement L. *History of Perry County Ohio.* New Lexington, OH: Ward & Weiland, 1902.

McKelvey, A.T. *Centennial History of Belmont County, Ohio, and Representative Citizens.* Chicago, IL: Biographical Publishing Company, 1903.

Meyers, David, and Elise Meyers Walker. *Wicked Columbus, Ohio.* Charleston, SC: The History Press, 2015.

Meyers, David, Beverly Meyers, and Elise Meyers Walker. *Look to Lazarus: The Big Store.* Charleston, SC: The History Press, 2011.

Miller, Edward H. *The Hocking Valley Railway.* Athens: Ohio University Press, 2007.

*Milwaukee (WI) Journal.* "Riotous Coal Miners." September 1, 1884.

*National Police Journal* 2, no. 1 (April 1918).

Nelson, Charles. *Buckeye Hill Country: A Journal of Regional History*. Rio Grande, OH: University of Rio Grande, n.d. http://www.oocities.org/athens/olympus/5870/nelson.html.

Nelson, Charles H. "The Story of Rendville: An Interracial Quest for Community in the Post Civil War Era." *Buckeye Hill Country* 1 (Spring 1996).

*New York Times*. "Soldiers at the Mines." September 2, 1884.

Ohio Memory. "Hocking Valley Strike Telegrams." http://www.ohiomemory.org/cdm/ref/collection/p267401coll32/id/2237.

Olcott, Charles Sumner. *The Life of McKinley*. Boston, MA: Houghton Mifflin Company, 1916.

Orton, Edward. *Report of the Geological Survey of Ohio*. Vol. 5, *Economic Geology*. Columbus, OH: G.J. Brand & Company, 1884.

Osgood, Richard H. "Some Recollections of the First Railroad Car Building in Columbus, Ohio, and of the First Railroads Built Into the City." *"Old Northwest" Genealogical Quarterly* 14 (n.d.).

Our History and Genealogy. "Southeastern Ohio Coal Industry and History." http://www.ohgen.net/ohathens/coalhistory.htm.

Phillips, Kevin. *William McKinley: The American Presidents Series: The 25th President, 1897–1901*. New York: Times Books, 2003.

Powell, Adam Clayton, Sr. *Against the Tide*. New York: Richard R. Smith, 1938.

The Rick Smith Show. "Women in the Coal Mines? Yes!" Daily KOS, April 23, 3015. http://www.dailykos.com/story/2015/4/23/1378067/-Women-in-the-Coal-Mines-Yes.

Rocchi, Julia. "Six Practical Reasons to Save Old Buildings." National Trust for Historic Preservation, November 10, 2015. https://savingplaces.org/stories/six-reasons-save-old-buildings#.VruDRuZWJps.

Roy, Andrew. *A History of the Coal Miners of the United States*. Columbus, OH: J.L. Trauger Printing Company, 1907.

Saliers, Earl Adolphus. *The Coal Miner: A Study of His Struggle to Secure Regulated Wages in the Hocking Valley*. Bethlehem, PA: Bethlehem Printing Company, 1912.

Schnapper, M.B. *American Labor: A Social Pictorial History*. Washington, D.C.: Public Affairs Press, 1975.

Skrabec, Quentin R. *William McKinley, Apostle of Protectionism*. New York: Algora Publishing, 2008.

Smith, Charles H. *The History of Fuller's Ohio Brigade, 1861–1865*. Cleveland, OH: Press of A.J. Watt, 1909.

*Springfield (OH) Globe-Republic*. "The Hocking Valley Trouble." August 2, 1886.

*Stark County (OH) Democrat*. "New Straitsville." April 1, 1875.

Stille, Samuel Harden. *Ohio Builds a Nation*. Lower Salem, OH: Arlendale Book House, 1939.

Studer, Jacob Henry. *Columbus, Ohio: Its History, Resources, and Progress.* Columbus, OH: self-published, 1873.

Taylor, William Alexander. *Centennial History of Columbus and Franklin County, Ohio.* N.p., n.d.

Tebben, Gerald. "Columbus Mileposts: July 19, 1877. Manufacturer's Predecessor Founded." *Columbus Dispatch*, July 19, 2012.

Tribe, Ivan M. "John Richards Buchtel: A Paternalistic Ohio Coal Operator." *Northwest Ohio Quarterly.* Maumee, OH. Available at http://www.ohgen. net/ohathens/johnrbuchtel.htm.

———. *Little Cities of Black Diamonds: Urban Development in the Hocking Coal Region, 1870–1900.* Athens, OH: Athens County Historical Society & Museum, 1988.

———. "Pride and the Golden Age of Coal: Coal Barons and Company Towns." *Buckeye Hill Country: A Journal of Regional History.* Rio Grande, OH: University of Rio Grande. Available at http://www.ohgen.net/ ohathens/coal.htm.

*United Mine Workers' Journal* (May 19, 1899).

Van Horn, Arnold. "Chapel Hill on Irish Ridge." Little Cities of Black Diamonds. http://littlecitiesofblackdiamonds.org/stories/chapelhill.html.

Vess, Mark. "The History of Moxahala." Little Cities of Black Diamonds. http://littlecitiesofblackdiamonds.org/stories/moxahalahistory.html.

Warne, Frank Julian. "The Union Movement Among Coal-Mine Workers." *Bulletin of the Bureau of Labor*, no. 51 (March 1904).

Watkins, Damon D. *Keeping the Home Fires Burning.* Columbus: Ohio Company, 1937.

Wheeler, B. Gordon. "Allensworth: California's African American Community." *Wild West* (February 2000).

Wikipedia. "Labor History of the United States." https://en.wikipedia.org/ wiki/Labor_history_of_the_United_States.

Williams, Meriah. "Historical Marker Dedication Set on Kachelmacher." *Logan (OH) Daily News Reporter*, June 7, 2009.

Wiseman, Charles Milton Lewis. *Centennial History of Lancaster, Ohio, and Lancaster People: 1898.* Lancaster, OH: CML Wiseman, 1898.

Zuefle, Matt. "I Reckon…San Toy: Ghost Town or a Black Diamond in the Rough?" *Athens (OH) News*, December 9, 2002.

# INDEX

# INDEX

# ABOUT THE AUTHORS

A graduate of Miami and Ohio State Universities, DAVID MEYERS has written a number of local histories and various works for the stage. Among the former are *Columbus*: *The Musical Crossroads* and *Ohio Jazz*, while the latter include *The Last Christmas Carol*, *The Legend of Sleepy Hollow Condominium Association* and *The Last Oz Story*. For twenty years, he was on the board of the Hocking Valley Museum of Theatrical History in Nelsonville.

Elise, David and Nyla. *Beverly Meyers.*

# ABOUT THE AUTHORS

ELISE MEYERS WALKER is a graduate of Hofstra University and serves on the boards of the Columbus Historical Society and the Ted Lewis Museum in Circleville. She and her father have previously collaborated on *Central Ohio's Historic Prisons*, *Historic Columbus Crimes*, *Look to Lazarus*, *Columbus State Community College*, *Inside the Ohio Penitentiary*, *Kahiki Supper Club* and *Wicked Columbus, Ohio*.

Raised in Union Furnace (where she graduated from high school), NYLA VOLLMER became immersed in the history of the Little Cities of Black Diamonds after moving to Haydenville in 1989. She is a nursing graduate of Hocking Technical College, co-founder of the Haydenville Preservation Society and a board member of the Hocking County Historical Society. Nyla has authored *Haydenville: The Last Company Owned Town*, *South Perry History* and *Reflections of Starr-Washington: Union City Schools*.